CONTENTS

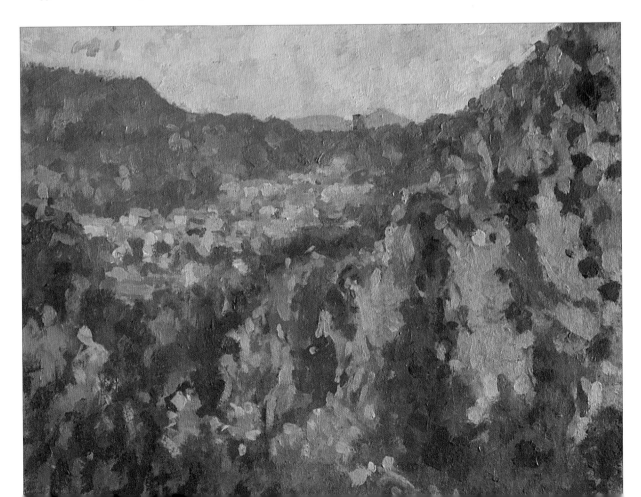

INTRODUCTION

One might say that the birth of modern landscape painting began with Turner and Constable and then proceeded to accelerate in development throughout the rest of the nineteenth century; so in terms of western art as a whole, landscape painting is still in its infancy. At the start of the twenty-first century it might be easy to think that there is nothing much left to do in the wake of such wonderful painters as the Impressionists and many others since. However, all artists have worked with the achievements of their predecessors looming large behind them and still gone on to find new challenges.

The fact is that we are surrounded by the landscape and can turn to it as a permanent source of inspiration, and as long as there are individual painters working with an independent eye we can always enjoy looking at, and creating, landscape paintings.

This brings me to the point where I try to explain what I hope to achieve by writing a book such as this. To try and teach painting comprehensively through the medium of a book is no more possible than teaching cabinet-making or any other subject where practical experience is necessary. However, what I hope to do is to lay the foundations of a solid technique that will enable the enthusiast to embrace any part of the subject without fear or intimidation and approach the landscape with reasonable expectations of achieving decent results.

When I am teaching, I often hear a student say that they chose a particular view because they felt it more approachable or easier than another. My feeling is that subjects that inspire you are the ones you really want to paint. In reality, there is not really any subject that is intrinsically more difficult than any other. There may be complexities or intricate aspects to a particular subject, but the actual business of simplifying and turning the literal into a painterly language will always remain the same. Any subject is possible; all that is required is to find the means to tackle it. Most important is to approach your subject in a positive way, which means not making a compromise before the painting actually starts!

The challenge of pitting your wits against the view in front of you and trying to turn it all into a picture is the most exciting thing in painting, in my opinion. In addition, let us not forget that when working outdoors the challenge is not always intellectual. A whole multitude of events can test your resolve; from inclement weather, things that block your view, to people who insist on holding a conversation. Hopefully I can help you to create a technique capable of dealing with the painterly problems by sharing with you my own approach and enthusiasm for landscape painting.

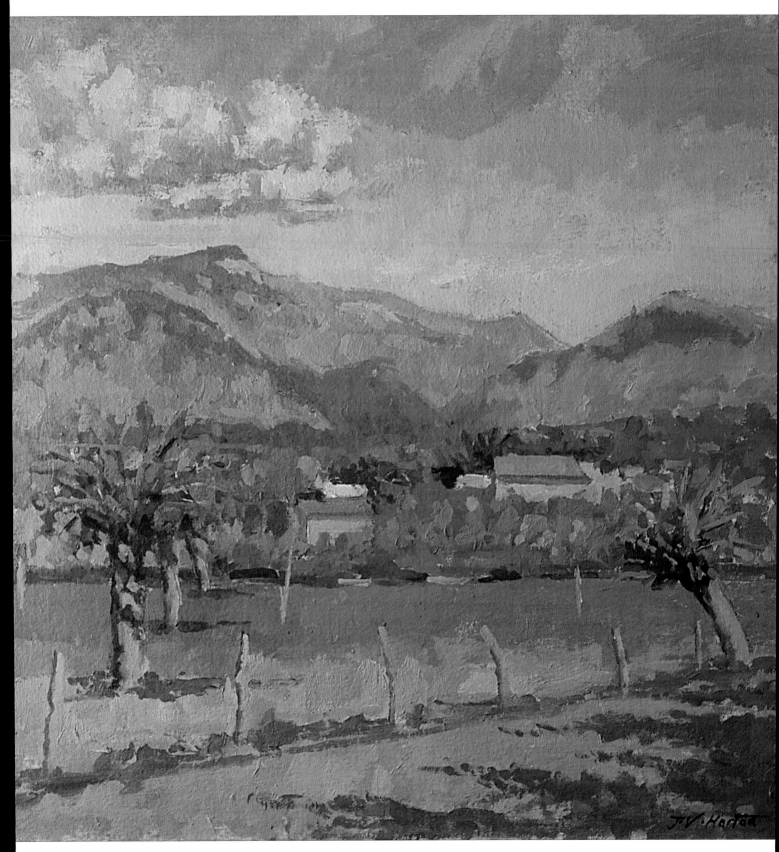

Bright and Windy Day, Can-Xenet, Majorca

45.7 x 38cm (18 x 15in)

The great challenge in this painting was to capture the fleeting clouds and resulting shadows on the hills. The ability to 'freeze frame' at any one point within your mind's eye is essential at times like this.

MATERIALS

Whatever the trade or nature of the work in question, a knowledge of the materials involved is essential to ensure good results. Whether a plumber or an artist, knowing how your materials perform and which tools to use will greatly enhance the results of your work. As an artist, and in this case as an oil painter, it is necessary to understand how the materials you will be using can create the effects you would like to achieve.

PAINTS

The composition of paint varies; some consist simply of pigment, some contain dye extracts and a binding medium. Which binder is used will define whether the paint is oil-based, watercolour or acrylic. Acrylic paints use a synthetic polymer binder.

The paint that will be used throughout this book is oil paint. This is any pigment ground mixed with an oil. Mostly this tends to be linseed oil; but other oils – such as poppy or sunflower oil – are sometimes used depending on the density and type of pigment used. These oils are the traditional binding media. In modern times a synthetic resin called alkyd has been developed. This still results in an oil-based paint, but alkyd-based oil paints dry more quickly than traditional oil paints once they are exposed to air.

There are two main grades of paint, known as artists' quality and students' quality. If possible it is always best to use artists' quality, because the handling and mixing potential is always better. If budget forces you to compromise, then students' quality earth colours such as umbers and ochres can be used, but try to use artists' quality for strong colours such as reds, blues and white. Whichever type of paint you choose, there is a huge range of colours available, but it is possible to paint any subject you wish with very few colours.

Note

In very recent times, paints have been developed with a synthetic binder which has the extraordinary property of mixing well with both water and oil-based products such as varnish or turpentine.

This is not interchangeable during painting – once started, either oil or water must be used consistently.

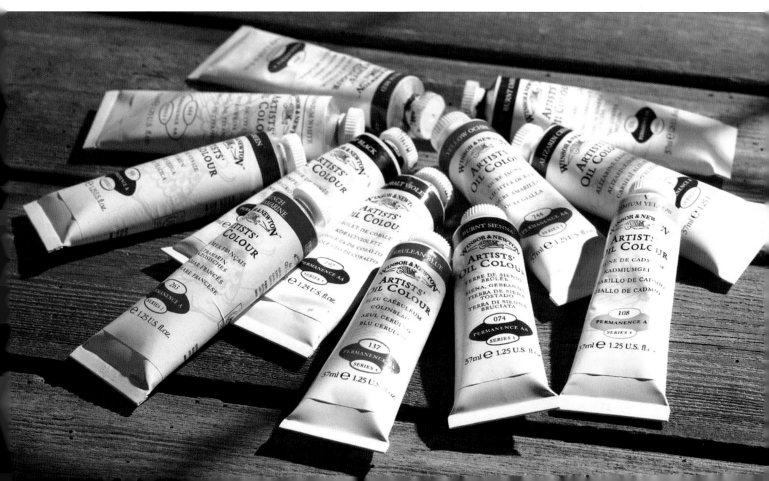

Artists' quality oil paints.

Drying times for oil-based paints

The issue of drying time is of paramount concern to oil painters. By 'drying time' I mean both the length of time the paint takes to dry on the canvas, which governs the amount of time you have to rework your painting; and also the actual chemical process of the paint oxidising in contact with air. This process can continue for many years, and is dependent upon the thickness of the paint.

Because of the different qualities and amounts of oil used in different paints, and the subsequent additions of other oils and varnishes used as you paint, there is a danger of creating tension between the drying rates of different layers. This can cause deep cracks on the surface as the painting dries, not just after a long period of time but relatively soon. In the worst cases cracks can appear during the actual working time of a painting. To avoid creating tension, oil painters tend to follow a golden rule, which is 'fat over lean', which means that you should always put thicker paint on top of thinner paint (see page 32).

Drying is also an issue in regard to practical matters such as transporting wet paintings, storing paintings, and how long you should wait before over-painting is possible. This practical issue may well be one that could influence your choice of paint. Faster-drying paints may make your working easier.

At this point I feel bound to say that in my opinion the qualities of traditional oil paints, along with traditional techniques and methods, are as flexible as anything that modern synthetic paints can achieve. It is possible to speed up or slow down the drying to whatever extent you wish using traditional methods.

If the fast-drying properties of alkyd-based paints sound attractive, then this may influence your choice. Bear in mind that alkyd can become quite sticky fairly quickly, especially on a warm day. If you then find it necessary to add in some sort of retarder to keep the paint moving, this arguably defeats the point of using fast-drying paint.

Similarly, water-soluble oil paints are often chosen in the belief that they will dry quickly if used with water. In my experience this is often not the case, and ironically they can take longer to dry than traditional oil paint.

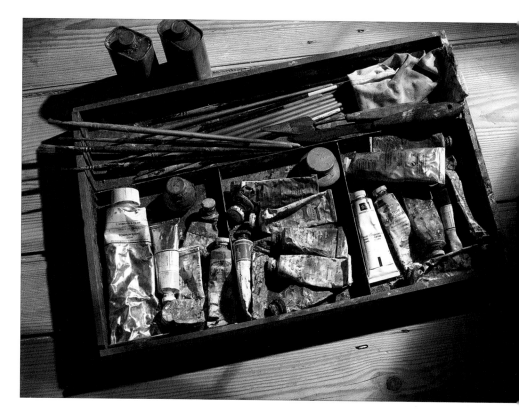

Paints stored in the inner tray of my box easel.

9

BRUSHES AND KNIVES

Paintbrushes

Most oil painters tend to use long-handled brushes because a lot of work is done at arm's length. Short-handled brushes are normally associated with working at closer range, such as with watercolour.

Today we have an excellent range of synthetic hair brushes which can perform just as well as the older styles of brush. Traditionally, larger and mid-range brushes for oil painting were made from hog's hair, while sable was used for fine detail brushes. Both natural and synthetic brushes come in flat and round shapes, which allow for different brushstrokes. There is also a brush shape called a filbert. This is basically a flat brush with the end tapering to a point, although very often this can occur naturally with the gradual wearing of a regular flat brush!

Normally size 8 or 10 brushes (flat or round) are used for laying in paint, while sizes 4 or 6 are used for mid-range marks. If careful or precise work is needed, a size 2 or 4 round sable brush can be used. Ultimately, all of this depends upon the style or type and size of painting you want to do.

One thing worth bearing in mind is that although it is possible to work with only three or four brushes, most oil painters prefer working with quite a few more – roughly eight or ten. This is because there are times when it is useful to save the colour on the brush for later use. This method of working has the advantage of keeping dirty white spirit out of your paint. If you do choose to use fewer brushes and repeatedly wash them out, be sure to dry them thoroughly to keep your work clean.

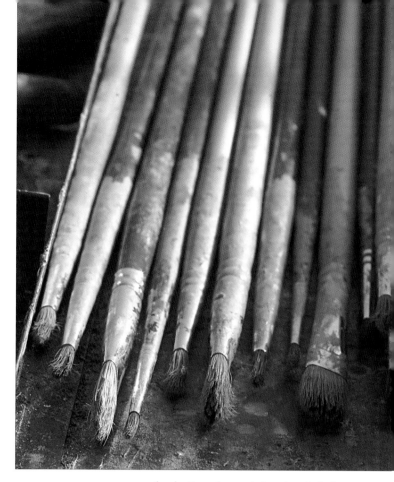

A selection of my paintbrushes, including round, flat and filbert brushes. A variety of brushes is always useful to have, to allow a wide range of different brushstrokes.

Note

Flat brushes were not in common use until Stanhope Forbes and the Newlyn School brought them into prominence in the early twentieth century. Since this time, they have been a regular part of a painter's kit.

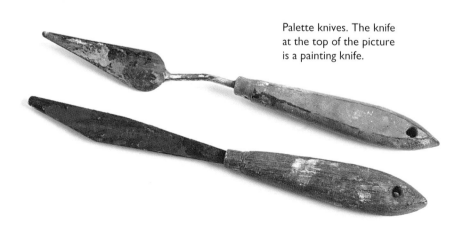

Palette knives. The knife at the top of the picture is a painting knife.

Palette knives

There are two types of palette knife. One has a straight blade from the handle and is used for scraping up paint from the palette. The other type is, strictly speaking, called a painting knife. This has a step in the blade so that your knuckles do not touch the canvas when applying the paint.

If painting with a knife appeals to you, then you may wish to acquire a selection of large, medium and small knives to cover all options of marks made.

EASELS

There is a huge range of easels available on the market, but the most important thing is to choose an easel that fits your working method. The easel you choose should have a reasonable range of adjustment of height to incorporate standing and sitting. For this reason tabletop easels are not ideal as they are limited in adjustment and cannot be used outside.

If you are fortunate enough to have a dedicated studio or workroom, then there is no doubt that a stable H-shaped easel is unbeatable, but for working outside, a lightweight easel is essential. These have the advantage of being collapsible for storage in a corner, and can be used inside or outdoors.

If you are looking for an all-round easel, suitable for both indoor and outdoor use, there are some amazingly lightweight metal easels available that are stable and easy to carry. Wooden easels can be heavy and awkward to carry around.

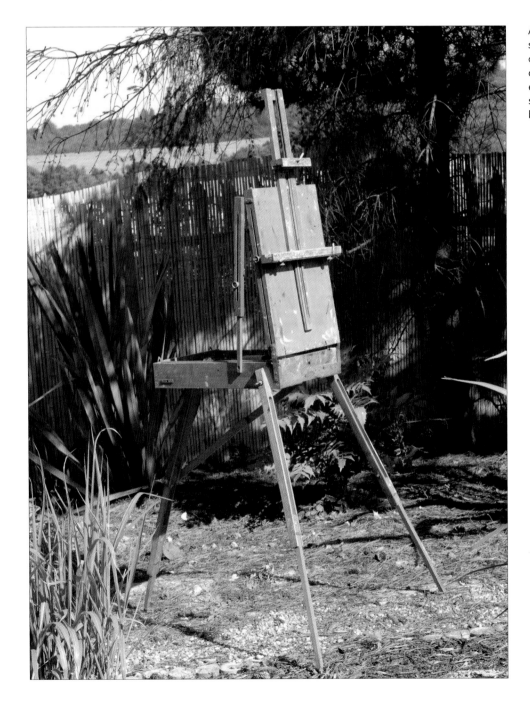

A box easel, such as the one shown here, is ideal for working outside. It is like a portable studio, containing all the necessary equipment and the means to support boards or canvases. It can be used while seated or standing.

PALETTES

A palette is an essential piece of kit for an oil painter. Traditionally, palettes were made from a hardwood, often mahogany. Solomon J. Solomon (1860–1927) in his excellent book *The Practice of Oil Painting* says you should never begin work with less than an 18 inch palette! Although a palette of this size may be impractical for many people, you should always use as large a palette as possible to facilitate and encourage mixing of colour.

I have a number of palettes, but my preferred one is the large 58cm (23in) square palette that I always use when working in the studio. When working outside I use either a 38 x 30cm (15 x 12in) or the larger 50 x 33cm (19¾ x 13in), both of which fit neatly into my box easel.

It is perfectly possible to use plastic or glass palettes, but the paint tends to skid around because there is no absorbency within the surface. Disposable paper palettes are also available and although they are convenient, they have an unsympathetic surface in my opinion. On a personal note, I prefer wooden palettes because they acquire the most beautiful polished surface over a period of years and become an old friend. It is also worth considering the aspect of colour here: because wood is a mid-tone (neither light nor dark) it is easy to see both light and dark colours when mixing. In contrast, a white surface – such as you get on a paper palette – affects the way colour appears, making it more difficult to gauge lighter colours.

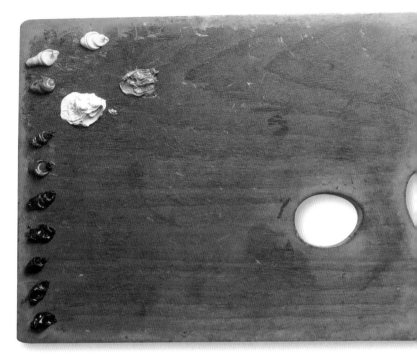

I always arrange my paints on the palette in the same way (see page 23). This helps me to mix methodically, because I always know where each colour is supposed to be.

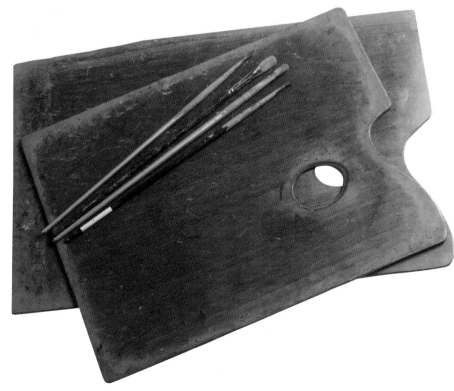

Shown here are the two palettes from my paint boxes. Both fit in my box easel, but I tend to carry around only the larger of the two in the field.

MEDIUMS AND SOLVENTS

Mediums

The term medium refers to any form of liquid added to the paint from the tube in order to spread the paint out (usually in the early stages) or just generally to make the paint more workable.

Mediums can be purchased in ready-made form. The commercially available artist's painting medium resembles the traditional medium that painters would have made for themselves, but there are many different types with different qualities. An example is liquin, which is a fast-drying medium made from alkyd resin.

Personally, I always make up my own painting medium because it allows me to adjust its strength to whatever I wish. My medium is made up from equal measures of dammar varnish and linseed oil combined with two measures of turpentine. You can vary the amount of turpentine, but do not over-thin the paint as this can start to break down the binding media within the paint. In extreme cases, this can mean that even when the surface is dry the colour can rub off on your hand. Therefore a medium that keeps up the fatty content of the paint is what is needed; this is why I use a fair amount of linseed oil in my medium mix.

Whether you use a ready-made medium or make one up yourself, consistency is the golden rule: try not to vary the strength of the medium during a painting. For this reason it is a good idea to make sure you have sufficient amounts of medium of the same strength prepared before you start a painting.

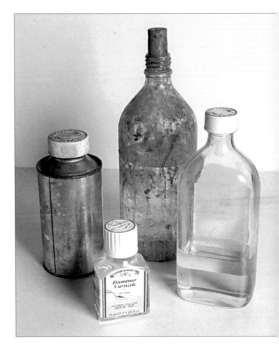

Some mediums and solvents, including the ingredients for my medium. From left to right: turpentine, dammar varnish, white spirit and linseed oil.

Note
Very often white spirit is referred to as 'turps', especially in the household painting trade. This is a leftover from the days when pure gum turpentine was used for thinning down paint and cleaning brushes. Do not get confused!

Tip
While it is perfectly possible to use turpentine as a dilutant to thin your paint it is not generally recommended as overuse gives the paint a meagre and dry appearance.

Solvents

Solvents are also known as diluents. For painters they have two purposes: to thin down the paint wherever necessary and to clean the brushes.

Pure turpentine is distilled from the resin of pine trees and is excellently suited to mixing with oil paint or any mediums, such as varnish or oil. Most painters tend to use turpentine substitute or white spirit to clean their brushes, as it is a great deal cheaper than pure turpentine.

White spirit is distilled from crude petroleum, thus giving it a far less pleasant smell than pure turps. In my opinion, it is best used only for cleaning brushes. In fact, white spirit is not fully soluble with dammar varnish, which makes its use within many painting media unsuitable – causing them to separate and not bond fully.

A note of caution: when using white spirit to clean brushes while working, try to avoid repeated cleaning as residue will sometimes remain on the brush and get through to the paint. This can cause patches of matt and dried-out colour. Always try to dry the brush as much as possible on a piece of rag.

When using white spirit on a regular basis, find an old pot or container to pour in the used liquid. If left undisturbed for several days, the sludge will sink to the bottom, leaving the liquid on top perfectly usable.

Most painters love the smell of paints or turps, but if there is a problem (or indeed any sort of allergy) then there are odourless products available. In addition, ensure that you have sufficient ventilation if using solvents indoors, as they can be unhealthy if breathed in.

SUPPORTS

It is possible to paint on almost any surface, provided it is isolated from the paint: in other words, the surface is primed (see pages 20–21). For many years after the invention of oil paint (roughly the mid-fifteenth century), the most common support was a wooden panel. If larger surfaces were required then several panels were joined together. Eventually, canvas was used to get around the problem of weight.

In many ways things have not changed a great deal; many artists still use a stiff support like wood or cardboard on a small scale, but change to canvas above a certain size due to the problems with weight and manoeuvrability.

Canvas is hydroscopic, meaning that it expands and contracts a great deal with changes in atmosphere such as temperature and humidity. Owing to this property, canvas must be stretched on a frame that has fixed corners which enable wedges to be tapped in. These wedges force the frame apart and take up the slack of the canvas. Ironically, while canvas has been the most popular support for oil painting for centuries, it is probably the least permanent support in preservation terms. When compared with wood and metal, it is very difficult to maintain.

Today we are fortunate enough to have synthetic wooden panels like hardboard or MDF. These are ideal to paint on and do not need seasoning like real wood. In addition, unlike canvas, these surfaces are not hydroscopic, making them ideal for oil painting.

In addition to these supports, there is a combination of board and canvas where the canvas is glued to either wood or cardboard to give a texture (see page 19 for the method). Like canvas, these canvas boards are available ready-prepared and primed, but you can prepare your own using the primer described on pages 20–21.

There is also the possibility of working on paper. This can provide both a cheap and lightweight surface to work on; and also a very beautiful one. It is best if you use a good quality paper, such as a medium to heavy watercolour paper, and then prime it with acrylic primer. This has to be done with acrylic paint as it is water based – oil will rot the paper. Two or three coats will create a surface that gives oil paints a lovely matt quality.

This shows a fully primed board with a blue–grey toner applied (see pages 20–21 for the method). Notice the slight blotchy effect. This is due to a water-based toner being applied over a slightly oil-based surface.

Note

During the Golden Age in Holland (mid-seventeenth century), copper was a popular support.

Canvas can be bought unprepared on rolls, or ready-stretched on a frame.

MATERIALS FOR PAINTING OUTDOORS

The materials for painting outdoors are not, in essence, any different from those used in the studio. Portability is important, so one must learn to take only what is essential for the job and perhaps discard many of the extras that one uses inside.

It is quite possible to work out of the back of a car and if this suits you, then well and good. However, sometimes your subject may only be approached by foot, in which case the amount you have to carry becomes an issue.

Transporting a wet painting back home is one of the biggest headaches for an outdoor painter. This is where the box easel shown on page 11 (and below) is a wonderful piece of kit. Alternatively, smaller paintings can be stored in the lid of a standard paintbox, such as the one shown here.

As well as your equipment, do bear in mind that standing still or sitting for long periods can make you cold, even in summer if there is a breeze, so always take plenty of warm clothing to ensure that you are comfortable.

Here is my paintbox, which I often use when painting outdoors. The beauty of a box like this is that it can hold two painting boards. You can also close the lid on the palette, keeping everything in place while you are moving.

The other advantage with this box is that it can be used while sitting down, resting on your knees with the painting contained within the lid. If you wish to work larger than the dimensions of the lid, then a separate easel must be used.

A viewfinder with one adjustable side is a very useful tool for deciding on compositions. See page 26 for more details on how to use one.

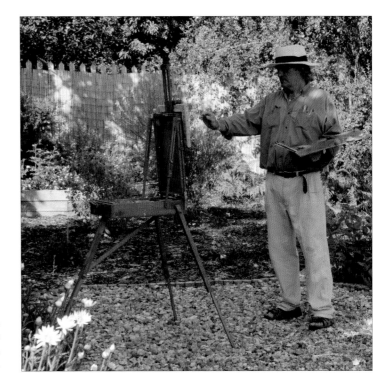

This shows me working at my box easel. This easel can take a canvas up to three feet in depth and as wide as you like. However, beware of strong winds.

OTHER MATERIALS

These pages detail some accessories that will come in useful while painting.

Masking tape This can be used to mask the edges of your work to produce a crisp border when removed.

Water pot While not useful for cleaning brushes, it can be handy to keep a pot of water nearby when preparing your own canvas.

Cleaning rag This is used to dry your brushes to prevent cleaning fluid polluting your painting.

Kitchen roll Again, this is very useful to help dry your brushes thoroughly.

Materials for preparing your own surfaces

If you want to make your own canvas boards on which to paint, you will need the following items.

Scissors A large pair of scissors is used for cutting the canvas and calico to the correct size.

Palette knife This is used to scrape excess primer from your canvas.

Hammer and tacks These are used to pin the canvas to the stretcher. See page 18 for the method.

Plastic mixing pot This is for shaking the oil, egg and water into an emulsion.

Metal mixing saucepan This is for mixing and warming the primer.

Rabbit skin size and eggcup Rabbit skin size is a glue made from desiccated rabbit skin. The eggcup is simply used for measuring the size.

Double boiler This is made up of two metal saucepans. The pan at the bottom is filled with boiling water, and the smaller pan sits on top. The size is prepared in the smaller pan to ensure that while it remains hot, it does not boil.

Calico This is pasted on to cardboard to make a support. It cannot be stretched on to a frame.

Canvas This can be used to make a board with a rougher texture, or can be stretched on a frame. I use calico and canvas because they are organic and have a sympathetic weave, but any natural, non-synthetic material is suitable for pasting on to board.

Whiting This is chalk powder, and is one of the constituents of the primer used to prime your canvas.

Zinc white This powder is the other main part of the canvas primer.

Metal tablespoon This is used to spoon the zinc white and whiting powders into the saucepan.

Large brush A large brush is used to spread the size and primer on to the canvas.

Thick cardboard This is the basis for the painting board. I use grey, acid-free, picture-framer's board, but any thick cardboard will do.

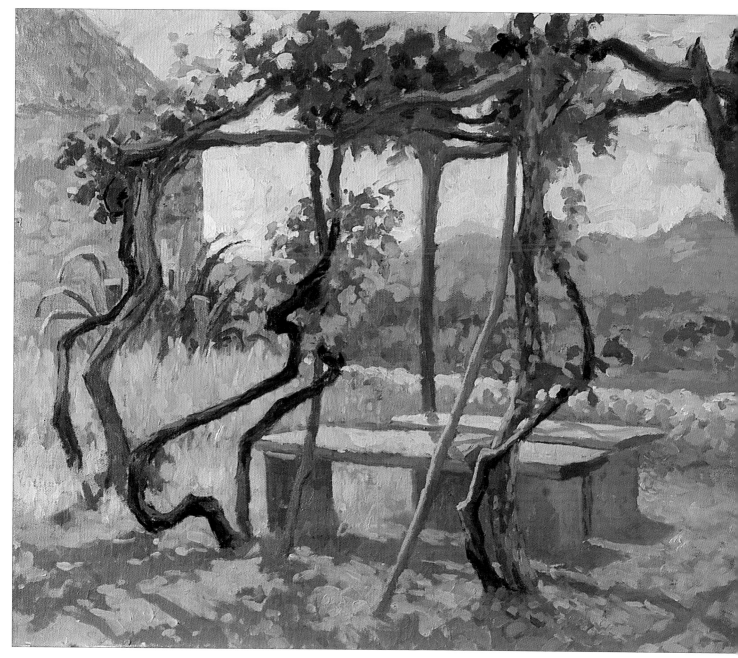

The Old Pergola, Can-Xenet, Majorca

55.7 x 45.7cm (22 x 18in)

Although the mountains are only a small part of this picture, their effect on the painting is considerable. Notice how the distant blue mountains are a good deal lighter in tone than the pergola and foliage. This gives a feel of mountain country.

PREPARING YOUR OWN CANVAS BOARD

Because a great deal of the work I do is outside, and often on trips abroad, I make up my own canvas boards. These give me exactly the surface quality I like and they are lightweight.

Sizing

Sizing removes the absorbency from the support, allowing you to prime and ultimately paint on the canvas or calico. I make my canvas boards from thick cardboard covered in calico, though I sometimes use canvas for a different texture. Rabbit skin size is used to remove the material's absorbency, and it also secures the calico to the cardboard. Before you begin, soak an eggcupful of size in a pint of water and leave to soak for an hour.

1. Warm the size in the double boiler, then use the large brush to saturate the cardboard with size and lay the calico over the cardboard.

2. Use the large brush to cover the entire surface with size, working out any creases.

3. Turn the board over, fold the edges of the calico over, and saturate the back of the board with size to hold the edges in place.

4. Turn the board over again, and work out any air bubbles.

5. Allow the board to dry for at least 24 hours.

18

Priming

Priming is what isolates the paint from the support, stopping the oil paint from rotting the canvas or board. If you wish to prime your own canvases or boards then the surface must be sized (see opposite) to remove the absorbency. Then there is a choice of primers. You can use either an oil-based primer, or an acrylic (water-based) primer. Modern oil-based primers will almost certainly be an alkyd resin.

Traditionally, a primer called *gesso* was used as a primer. Gesso is made with glue size (usually rabbit skin) and chalk whiting and was, in fact, referred to as a chalk ground. This still makes an excellent primer for stiff supports but is not really suitable for canvas because it is too brittle and may crack when the canvas moves. Here I show you how to mix your own traditional gesso.

This section describes how to make the traditional egg oil primer used for centuries by artists. Mostly it is used on rigid surfaces but can be used on small canvases, provided it is not rolled – this will cause it to crack.

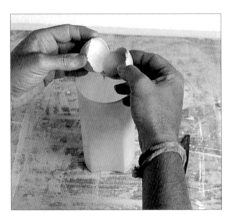

1. Carefully break an egg into the plastic mixing pot. Because all of the measurements depend on the size of the egg, you must be careful not to shatter the shell.

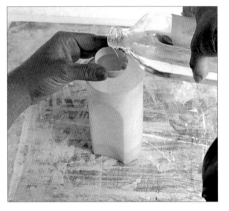

2. Fill each half of the eggshell with linseed oil and pour it into the mixing pot.

3. Fill each half of the eggshell with water and pour it into the mixing pot, then repeat so there are two measures of water in the mix. Close the lid and shake the pot vigorously to emulsify the gesso.

Note

Traditionally, white lead in linseed oil was used as a primer, but due to the danger of the lead content this is very difficult to obtain nowadays.

4. Pour the mixture into the metal pan, and add a heaped tablespoon of whiting with a metal spoon. Stir until the whiting has dissolved.

5. Add an equal amount of zinc white powder and stir until dissolved. Continue adding equal amounts of whiting and zinc white powder until the mixture is a thick white paste.

6. Add warm rabbit skin size to the paste to thin it to the consistency of single cream.

7. Immediately use the large brush to apply the gesso to your sheet of cardboard.

8. Cover the entire piece of cardboard and apply a second coat while the first is still drying. Allow the gesso to dry thoroughly.

Tip

Any water-based substance can be used to tone your board: acrylic paints, ink, watercolour paints, even tea or coffee. The important thing is that the material leaves a stain.

9. Once dry, use watered-down acrylic paint to tone the board. Use a neutral, mid-toned colour. This provides a good base to work on.

STRETCHING CANVAS

Canvas can be bought either ready-stretched and primed, primed but not stretched, or raw without any treatment at all. If you wish to prepare your own canvas you will need to decide which sort of surface you require. The finest grade (and most expensive!) is Irish linen. There are other grades of linen and also a material called cotton duck, which has a medium texture or 'tooth'. Finally there is hessian, which is coarse-grained and was much favoured by the Venetian artists such as Titian and Tintoretto. This section explains how you stretch your canvas. Once stretched, the canvas will need to be primed in the same way as the canvas board.

Stretching the canvas

This shows how to stretch raw (unprimed) canvas. Remember that once stretched, raw canvas must be sized and primed before it can be painted. Most acrylic or oil primers available from art suppliers are suitable for priming canvases. The egg/oil primer (pages 19–20) is not suitable for larger canvases, but could be used on small canvases.

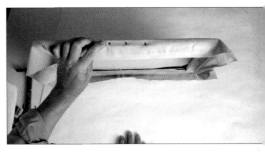

Tip
Do not use canvas pliers when stretching raw canvas, as this will cause over-tightening when the size and primer are applied. Ordinary finger tightness is quite sufficient.

1. Lay your frame over the canvas, and use the large scissors to cut the canvas to the correct size, leaving a small border all around the frame.

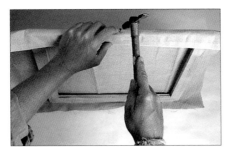

2. Fold the machined edges over the top and bottom of the frame, then stand the frame up and hammer in a tack in the centre of the top side of the frame.

3. Turn the frame over and repeat this on the opposite side, making sure that the canvas is tight. Hammer tacks into the centre of each side, then return to the top side and hammer in a tack on either side of the first.

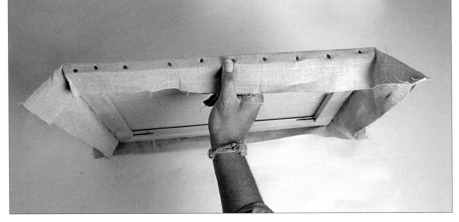

4. Continue across the whole edge, hammering in a tack every 5cm (2in). Repeat on the other three sides, making sure that the fabric is tight at all times.

5. Place the canvas flat on the table, fold the flaps in, and hammer a tack in each corner to finish.

COLOUR

Colour is a vast subject upon which many books have been written; my main aim here is to try and explain a little of the theory strictly in relation to observation. We tend to take colour for granted, as we see colour all around us all the time in our everyday lives. We tend to talk about and refer to local colour: identifying a 'red shirt' or 'blue trousers' or a 'green field' and so on.

As painters, we should try to look beyond the obvious naming of colours and explore the subtleties and variations within colour groupings. So instead of thinking 'this is a blue shirt', try to see all the variables within the light and dark areas, how these areas contain variations of the basic blue, and also whether these subsidiary colours are warm or cool. In addition, we try to see not only the variations within a general colour, but also how these colours relate to other colours surrounding an object.

Of course, we ultimately all see colour differently (or to be more precise, we interpret colour differently). This is just as well, otherwise everyone's pictures would look the same. However, within anyone's chosen range of colour there should exist colour values. This is to say the relative lightness or darkness of one colour against another as observed from life. An analogy I often use is to compare this to a tune in music. It is possible to play the same tune deep down in the bass levels or high up in the treble. In either case the tune (i.e. the intervals between the notes) remains the same regardless of pitch. The same can be said of painting, whereby the intervals between the colours remain constant regardless of pitch.

THE COLOUR WHEEL

In order to explain some of the rudiments of colour theory, a colour wheel is shown here to illustrate how the principles of primary, secondary, tertiary and complementary colours work.

To create a colour wheel such as this, you will need the three primaries, red, blue and yellow. Primary colours cannot be mixed from other colours. To begin, red, blue and yellow are put into the three inner triangles with white left in the middle. Then each of the primaries is mixed with the adjacent primary to form the secondaries – purple, orange and green. These are placed in the outer triangles that link the smaller ones. Finally, the secondary mixes are mixed with the primary on either side to achieve the tertiary colours and complete the wheel.

If you identify one colour and then look at the colour directly opposite it on the wheel, you will find its complementary colour. Complementary colours can be used to deliberately create a pleasing effect when seen together, such as purple and yellow, and blue and orange.

Colours are also referred to as either warm or cool. Blue is a cold colour, but there are degrees of colour temperature. For instance, French ultramarine is a warmer blue than either cobalt or phthalo blue, because it has a small amount of red (a warm colour) in it. Cadmium red and orange colours are warm, whereas alizarin crimson and permanent rose are cool. Yellow ochre is warm while lemon yellow is somewhat cool.

Many abstract painters make good use of these effects, as they have the possibility of creating their own colour scheme. However, it is surprising how often these effects occur naturally and are well worth picking up on. See page 73 for further details.

MY COLOUR PALETTE

My palette has not varied greatly since I began painting and is made up of a range of paints that enables me to mix any colour I encounter. Sometimes one sees very bright or strident colours, especially when working somewhere like India. In these cases, I may add the odd exotic colour to help with a strong local colour that is difficult to achieve by mixing.

The colours shown here are the ones that I generally use; and are (clockwise from the bottom) ivory black, phthalo blue, French ultramarine, cobalt violet, permanent rose, cadmium red, Indian red, yellow ochre, cadmium yellow, lemon yellow, grey and titanium white. I am not wedded to these colours and do change one or two from time to time. However, this is always in the form of a substitution (Venetian red instead of Indian red, for example) and I would never work with more colours than shown here.

The grey I use is a colour I make myself. When I finish a work, I scrape any remaining paint from the palette and store the mix in a glass jar. This means that I always have a ready supply of a neutral grey to use, and do not waste any of my oil paint. I always put this nearer the middle of my palette, since it is often used over the course of my painting. It is referred to in the projects as 'palette grey'. You can make some in the same way (from leftover paint), or mixing together a tiny amount of all the colours mentioned above.

MIXING GREENS

Making greens is one of the most vexed issues for a landscape painter. Generally, I would always advise against using ready-made greens and encourage you to learn to mix your own. Viridian hue is popular with many painters but personally I find it can be intrusive and gets into everything. There is also the possibility that having ready-made greens to hand can encourage laziness in mixing, and it becomes easy just to use what is available.

The obvious way of mixing greens is to use blues and yellows, but many people do not realise how effective black can be when mixed with various yellows. The beauty of black is that it gives a neutral effect to the greens, whereas blue will always tend to make cool greens. Whichever way you mix your greens they can, of course, be warmed with red. The chart illustrated here shows a very basic breakdown of the type of greens made with blue, black and yellow but as with any discipline practice makes perfect. There are literally hundreds of shades that could be achieved with the colours shown here. However, the real test is to go outside and try to match what you see rather than work to any preconceived ideas or formulaic method of achieving green.

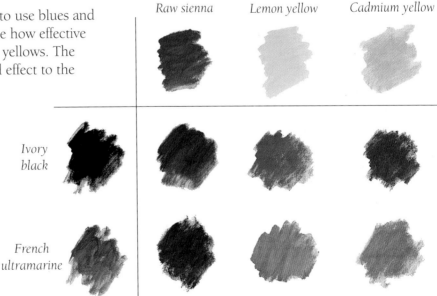

This chart shows the shades of green produced when ivory black and French ultramarine are mixed with various yellow paints. Neutral greens are produced when yellows are mixed with ivory black, while cool greens are produced by combining yellows with French ultramarine.

USING COLOUR TO CREATE AERIAL PERSPECTIVE

The term 'aerial perspective' is used to describe how colours become less intense as they recede into the distance. This often results in a bluish or purple quality in objects that are very far away.

As a painter I am very concerned with colour, and in particular spatial colour. As a consequence, most of the paintings in this book will show aerial perspective to a greater or lesser degree (see *View from the Villa del Monte, Rufina, Tuscany* on page 65 for a particularly striking example).

As painters, we should always be objective when considering colour values – the way one colour looks against another; whether it is brighter or more subdued; darker or lighter. The more you compare colour within your subject, the better the 'fix' will be in relation to pitch. In relation to aerial perspective this means that if the tones and colours in the landscape you are painting are correctly observed, you will automatically establish a degree of aerial perspective.

Note that just as parallel lines appear to converge as they recede from the eye, so too will colour alter in relation to the effects of ordinary, or 'linear' perspective. Generally speaking, colours tend to become greyer and less intense and often acquire a blue or purple hue as they recede. This is worth remembering if you have to work on pictures away from the spot.

Late Afternoon Looking Toward Wells from Blakeney
30.5 x 25.5cm (12 x 10in)

This painting has been developed in quite a high key (i.e. lighter tones), and a muted range of colour. The bluish character of the distance helps to create space, distance and recession. Even in full daylight, objects and areas in the distance tend towards blue, but the more the light begins to dwindle, the greater the blue-grey effect.

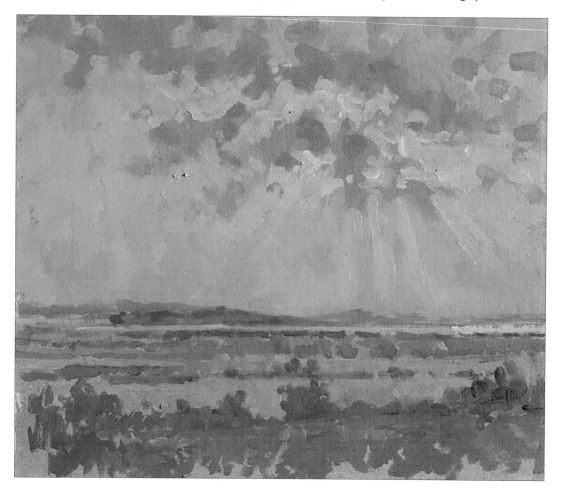

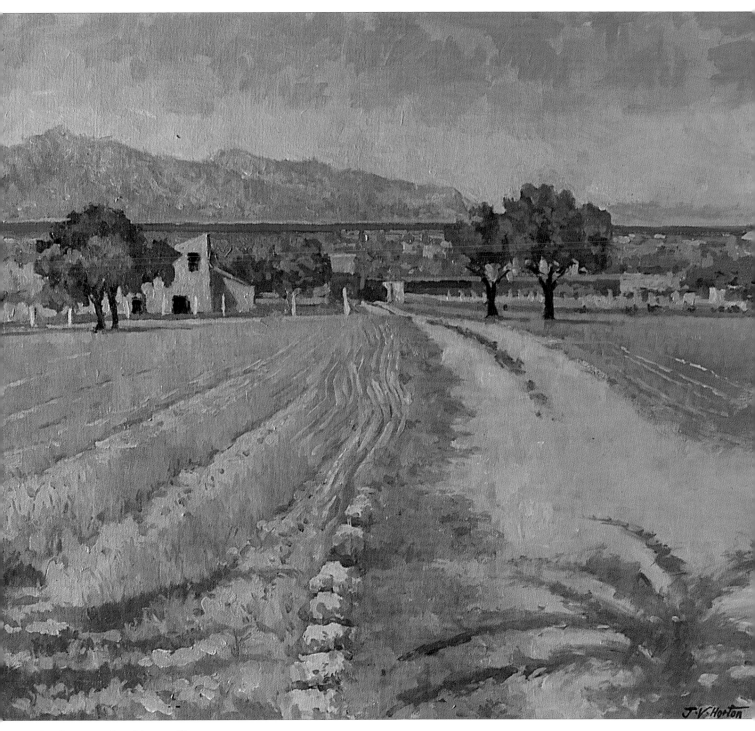

The Drive at Can-Xenet, Majorca

26 x 22cm (10¼ x 8¾in)

As well as the use of typical aerial perspective, this picture also uses linear perspective to aid a sense of recession. Notice how the cast shadows help to create a foreground.

COMPOSITION

Composition in painting is a rather difficult thing to define. The further one goes back into history the easier it becomes to distinguish a good composition from a bad one. The 'rules' were much clearer and better defined. In modern times, particularly with the ever-present influence of photography, it is much more difficult for a painter to know what is expected of him or her.

Although one might be reluctant to define a good or bad composition, I think it is possible to identify one that is interesting, complex and well thought out. If a composition satisfies all these criteria and the artist can honestly say that it does all the things he wanted it to, then it would be fair to say that such a composition is successful.

I often feel that the shape and proportion of the canvas (e.g. long and thin, square etc.) will have a character that can suggest certain ideas about geometry, tension and negative shapes and is similar to that of a key for a composer in music – some artists will like a certain shape, just as a musician will like a certain sound. Regardless of the shape of the canvas and what is being painted, the important thing to remember is that a composition must adequately fill the whole space of the canvas and have the feeling that the content belongs there and is held there by its own geometry and armature.

> **Note**
> Positive shapes are objects such as trees, buildings and people. Negative shapes are the shapes made by the space left around positive shapes.

USING A VIEWFINDER

Very often landscape painters will use a viewfinder. This is an excellent way of seeing how your composition will look within your chosen format. The essential thing to remember is that the shape of the window in the viewfinder must be the same proportion as the canvas. This is why it is important to have an adjustable viewfinder.

A viewfinder is made up of two rectangles of cardboard held together with a bulldog clip. Each piece of cardboard has a rectangular hole cut in it, so by moving one in relation to the other you can change the shape of what is visible through the viewing hole.

The following photographs show how a viewfinder is used. Simply hold it a comfortable distance away from yourself and move it until you are happy with the scene you can see through it.

If you move your viewfinder near to or further from the eye, you increase or decrease the amount observed.

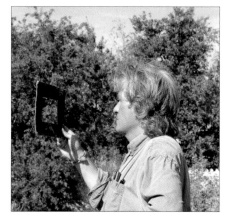

Roquebrun, France

20.2 x 25.5cm (8 x 10in)

This picture uses the classic motif of parallel lines. The vines, road and wall all align and lead the eye
into the composition. Notice how the eye level is set quite high to make the most of the foreground.

The View of the Mountains through the Pergola, Can-Xenet

56 x 45.7cm (22 x 18in)

This composition uses a 'frame within a frame' technique to enhance the space between the foreground and the distant mountains. By playing off the horizontals of the distant fields, wall and benches with the verticals of the vine and pergola it creates an abstract effect almost like that of Mondrian and Ben Nicholson.

OBSERVATION &
COLOUR VALUES

One of the most exciting, but also frustrating, aspects of working outdoors is the changing light. In a country like England, stability within the weather during a working session is very rare. How often painters have longed for the long sunny days that the Impressionists enjoyed in the south of France.

The key to coping with changing light is not to chase the light by altering the picture every time the light alters. Instead, try to observe the key points each time the light returns to where you want it and maintain a consistency of observation. Some parts of a scene will remain more constant than others, and these are the parts you can work on while waiting for the key elements to stabilise.

Secondly, it is never advisable to work too long on the same picture even if the light is stable, because the quality of light will alter as the day moves on. Two to three hours is the ideal time for working straight from life. If you cannot complete your painting in one session, try to return at the same time the following day.

One of the most important factors in establishing a good working pitch as early as possible is to compare and contrast different parts of a scene and work uniformly all over the canvas, rather than completing one detail of the composition before moving on. You will see this procedure in use in most of the projects. Although it is possible to alter anything at any time in oil painting, it is such a good feeling if the painting starts well and progresses smoothly without too much struggle to develop the basics.

The Creek at Morston, Norfolk
61 x 40.5cm (24 x 16in)

The light was very changeable during this painting and I had to be careful to keep my observations consistent, particularly in relation to the distant Blakeney Point where the sun lit up different parts of the landscape at different times.

The Long and Winding Road
25.5 x 15.2cm (10 x 6in)

This painting was done in mid-winter on a bleak road in the Fens. The sky at first seemed a leaden grey, but after a while the eye becomes very alert to the subtle differences of pearly greys.

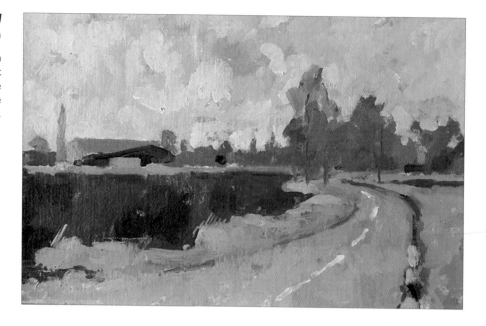

Beach Huts at Walberswick
91.5 x 76cm (36 x 30in)

Despite its size this picture was painted entirely on the spot. I had several days of constant light – very important for the shadows – and was able to achieve a freedom and fluidity of brushstrokes quite different from that possible on a smaller canvas. A painting of this size enables you to resolve areas more thoroughly into greater detail.

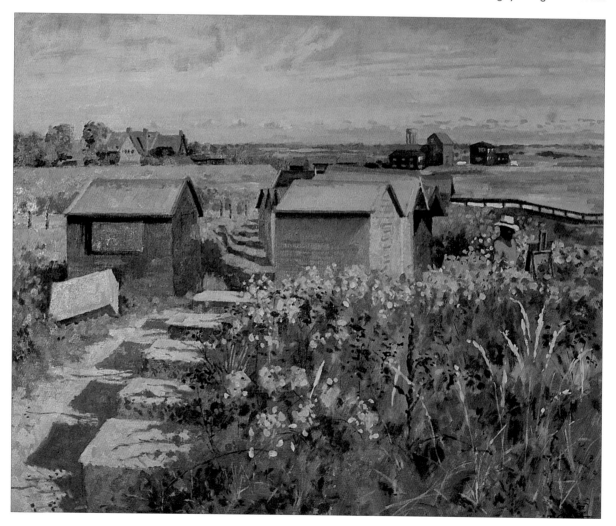

TECHNIQUES

As stated earlier the golden rule for oil painters is 'fat over lean'. This simply means that you always put thicker paint over thinned paint, and not the other way around. Not only does this make sense for the consistency of drying but in practical working terms it is easier to apply thick paint over a thinner base.

I always start with a quick brush drawing using paint thinned down a great deal using turpentine or sometimes medium. This can be rubbed out easily as many times as you wish. If you are hoping to complete a painting in one session then it pays to pace yourself with the application of colour. If too much is put on too quickly, then the surface can become greasy and saturated and may not accept any more paint. This is particularly frustrating if you are trying to correct or make precise, fresh brushstrokes.

With a gradual build up of paint, the confidence of your statements can grow, along with accumulation of paint on the surface. Ultimately there are no hard rules for applying paint to the surface because everyone is an individual and this will always show in the way you work. The following suggestions will help to highlight some particular stages of working.

Detail from* Rooftops in the Snow *project

This close-up of the quick brush drawing of *Rooftops in the Snow* shows how thinned paint has been used to sketch out the basic shapes of the composition. Rubbing this thinned paint with a rag allows for simple corrections to the work that would be impossible at later stages of painting.

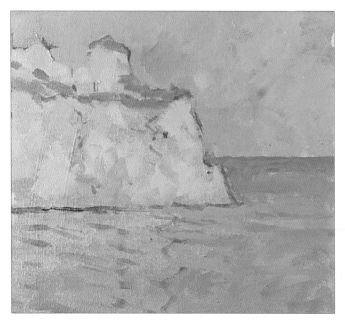

Detail from **Clouds Over the Quarry** *project*

A small amount of medium has been added to the paint at this early stage of the painting. This allows me to create the first statements, while the paint remains thin enough to allow me to overpaint later if I decide it is necessary. Concentrate on broad statements of colour and work across the whole canvas rather than details.

Detail from **Cliffs and Sea** *project*

Less medium is added to the paint at this stage of a painting. The paint easily covers previous thinned layers and allows you to begin tightening the picture (see pages 34–35 for more details on tightening a painting).

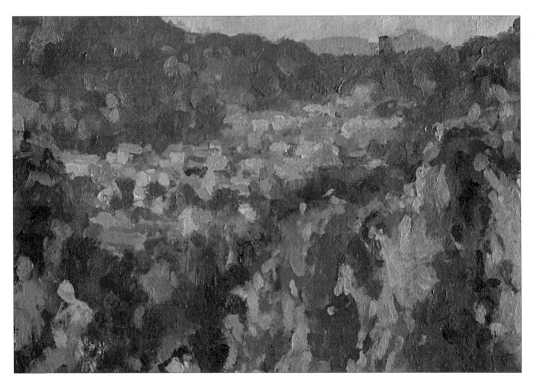

Detail from **Mountain Village in the Languedoc**

This section of the picture shows the multiple layers of paint, working from the earlier broad statements down to smaller but well-defined patches of paint. At this final stage, no medium is used, only the natural consistency of the paint.

TIGHTENING A PAINTING

These small sections are taken from the paintings opposite, and show the difference in tightness that has been used in each. When painting, each brushstroke makes a statement. Tighter paintings have firmer marks and the brushstrokes are more controlled. Often, but not always, they represent the object more literally. In essence, tightening a painting breaks down broad statements into smaller units.

The two paintings opposite show the same subject but painted from different angles, which makes the comparison interesting. Notice the difference in size between the pictures, which in part accounts for the different handling.

Buildings

Looser Tighter

Foliage

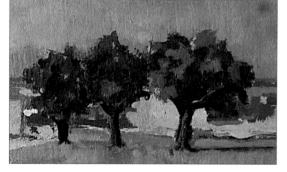 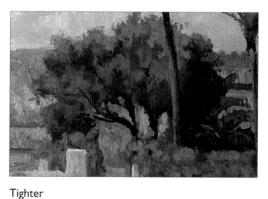

Looser Tighter

Foreground

Looser Tighter

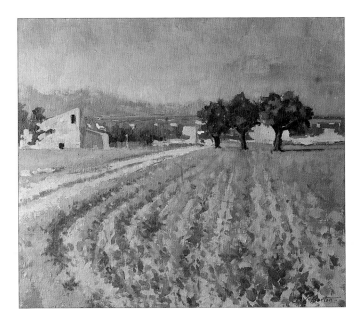

The Drive, Can-Xenet

40.5 x 35.5cm (16 x 14in)

This was a good chance to use some lively brushwork in the foreground. Paintings do not always have to be tightened up to precise detail. Knowing at what level to resolve a painting in relation to its size is very important.

The Approach to and Four Palms of Can-Xenet, Majorca

66 x 56cm (26 x 22in)

This composition makes use of a strong horizontal, just off the midpoint. This divides the painting strongly between foreground and distance. The idea here was to enjoy painting the more detailed stones and plants, while using the furrows in the soil to carry the eye into the picture.

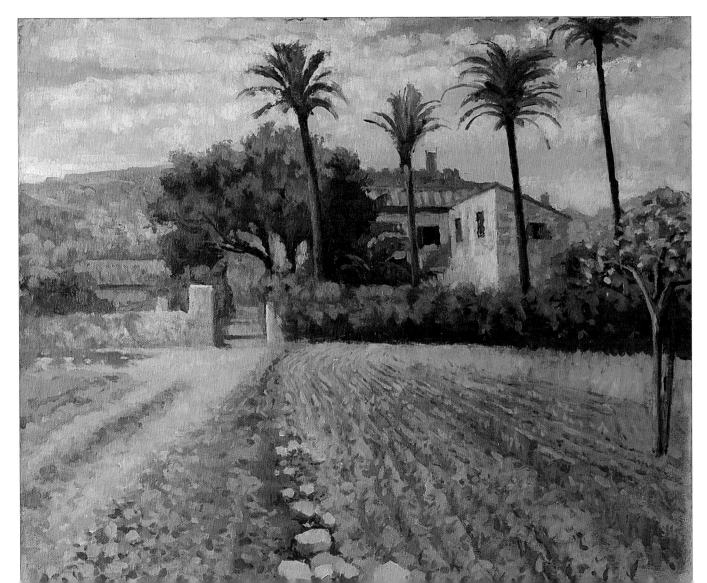

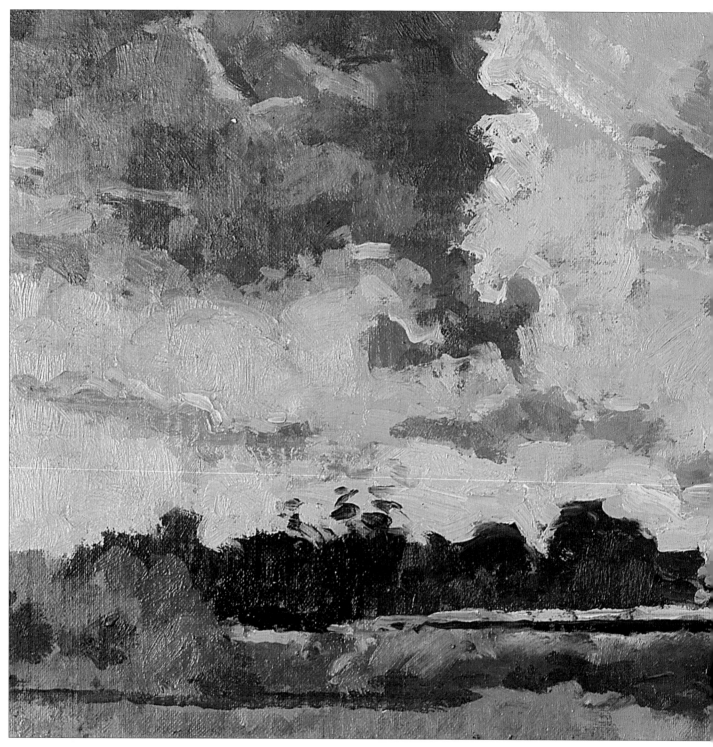

Evening Over the Sea Wall, Walberswick

25.5 x 20.2cm (10 x 8in)

This is, in effect, a pure sky study as the landscape below does little more than to anchor the sky.
However, without the landscape the picture would have been far less interesting.

<div align="right">

Opposite:

Late Afternoon Rooftops, Marrakech

30.5 x 25.5cm (12 x 10in)

This was painted from the roof of the Riad I was staying in. It is good to give the sky an anchor,
even though the rooftop, trees and tower are loosely suggested, that is all that was needed.

</div>

John Constable once said that the sky was the chief organ of sentiment in any picture. Painting in East Anglia, where one sees so much sky, he was only too aware of the importance it has in a painting.

The sky plays an important part in all our lives, and whether it is filled with thunderclouds or a stunning sunset, we are continually aware of it. As landscape painters it is always a challenge to try and capture a particular sky in all its subtlety. There is also the added challenge of movement in the sky – sometimes very rapid movement.

Constable was the son of a miller and grew up in the country. Consequently, he observed the sky day after day. He was probably the first artist to make serious studies of clouds and skies to try and gain extra authenticity in his paintings. I remember once looking at the paintings of Sir Peter Scott, the bird artist, and thinking how wonderfully plausible his skies were. Once again, he was a man who spent a great deal of time outside observing.

Like Constable, I feel that we should all make little sky studies of cloud structures, colour formations and so forth to improve our knowledge of how skies work.

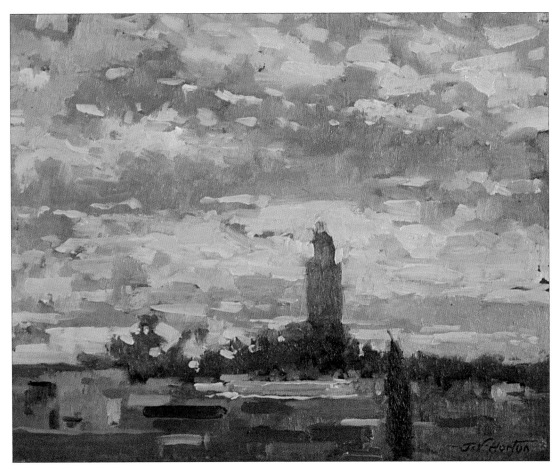

Clouds Over the Quarry

This is an exercise in creating cloud structures with relatively few colours, and also achieving solidity with simple, broad brushstrokes.

Useful mixes on the palette

Warm field mix

Cloud mix

Cool field mix

Sky mix

Sky highlight mix

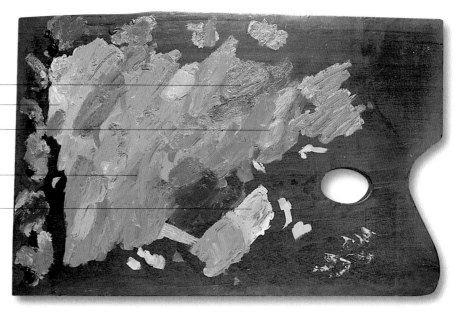

You will need

Canvas, 30.5 x 25.5cm
(12 x 10in)

Medium mix (see page 13)

Brushes: size 2 round,
size 4 flat

Colours: French ultramarine,
ivory black, phthalo blue,
cobalt violet, permanent rose,
cadmium red, yellow ochre,
Venetian red, cadmium yellow,
lemon yellow, titanium white

Medium painting knife

Clean rag

1. Sketch out the rough shapes of the landscape and cloud formations with a size 2 round brush and French ultramarine.

2. Mix titanium white and cobalt violet into the French ultramarine on your palette, and use this mix with a size 4 flat brush to block in the area of sky at the top of the painting. Vary the tones by adding more French ultramarine and a touch of ivory black for the very darkest shades at the top right. Paint the sky above the horizon in a lighter tint by adding lemon yellow to the original French ultramarine, titanium white and cobalt violet mix.

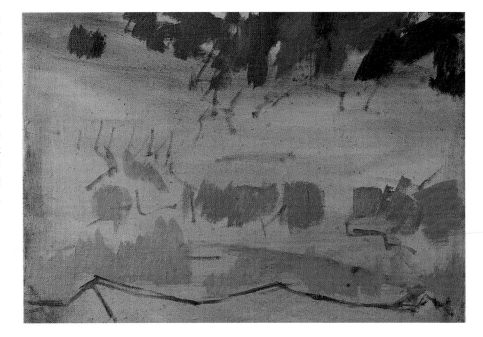

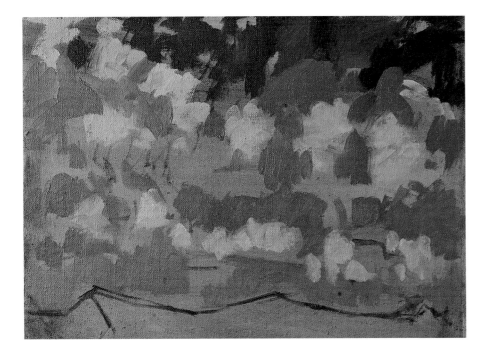

3. Still using a size 4 flat brush, begin painting the clouds with a titanium white and yellow ochre mix. Continue varying the sky by adding phthalo blue to the sky mixes you have on your palette. To incorporate the colours of the clouds into the sky, add yellow ochre to the sky mixes.

Tip

If you want to portray a faster-moving sky, then it is not necessary to sketch out the clouds beforehand, since they will be unrecognisable later on.

4. Continue filling in the sky, continually varying the main sky mix with the addition of phthalo blue and touches of yellow ochre and ivory black. Switch to the size 2 round brush and use a mix of cadmium red, titanium white and yellow ochre to block in the quarry on the lower left of the painting. Add some of the darkest shades used in the sky to this mix for the shadow of the quarry.

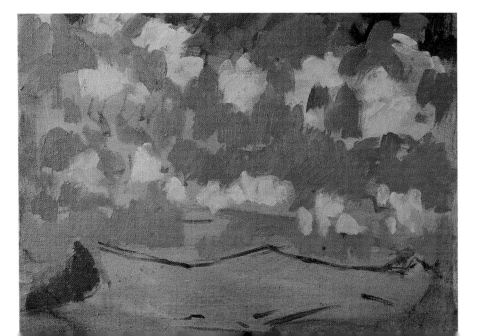

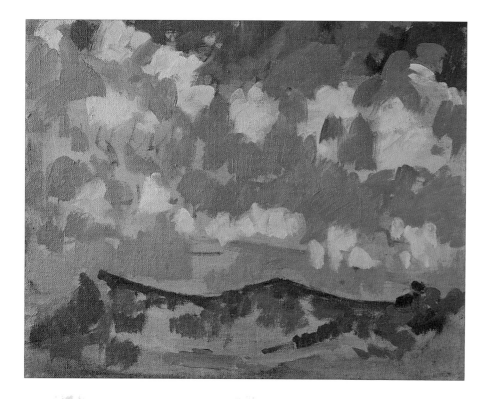

5. Block in the main colours on the ground using a size 4 flat brush and a mix of lemon yellow and ivory black, varied with the addition of phthalo blue and titanium white. Add Venetian red to this ground mix and use this shade to add in a darker line on the horizon and add shadows and texture to the ground, paying particular attention to the darker hillsides. Drop in the foreground fields with a mix of cadmium yellow, cadmium red and yellow ochre.

Tip

Keeping your brushes and medium clean is essential for a fresh finish, so rinse and dry the brushes thoroughly before using them with a different colour of paint. Alternatively, have a number of brushes on hand for different colours.

6. Using the same mixes as for the ground in the previous step, add touches of French ultramarine and yellow ochre, and refine the landscape. Begin comparing the tones of the sky and the ground and ensure the painting as a whole works harmoniously, lightening or darkening the colours used in the sky and the ground as necessary. Continue tightening the clouds and sky with the sky mix, and add more titanium white to lighten the sky.

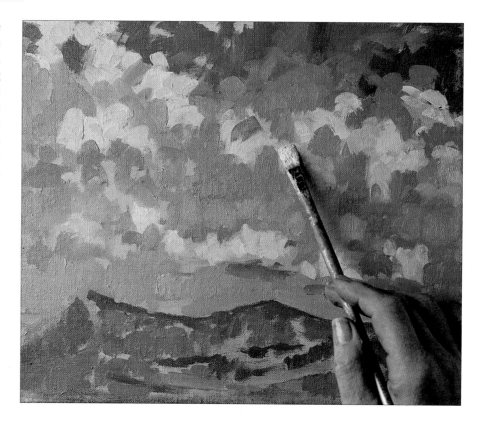

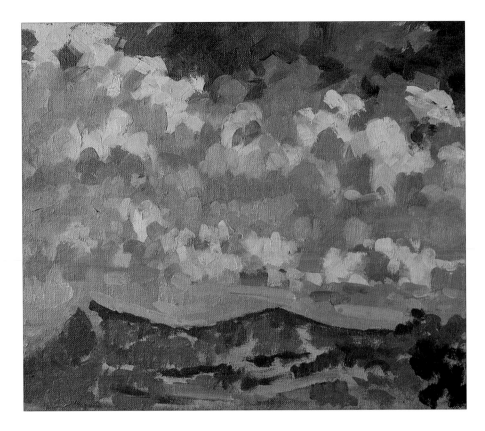

7. Still using a size 4 flat brush, strengthen the relationship between the ground and sky by adding yellow ochre to warm the cloud mixes. While painting, try to build the relationships between the initial blocks of colour. Touch and re-touch each part to incorporate it into the whole, and vary the size and direction of the brushstrokes you use. This will help keep the painting fresh and vital.

8. Using a size 2 round brush, begin softening the hard edges of the clouds with more subtle mixes of the sky colour. Tighten the painting with progressively smaller brush strokes and still more subtle mixes of the sky colour.

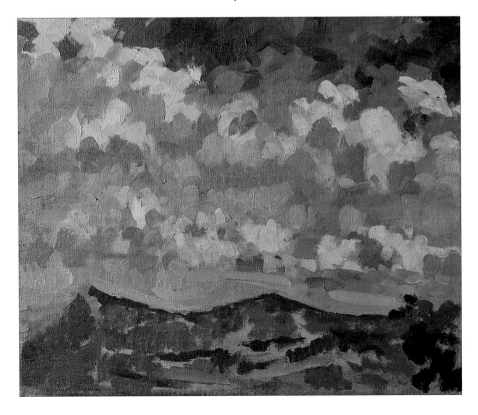

Tip

Notice how the toned ground of the primed canvas prevents bare white canvas from influencing your colour choices. Do not feel that you have to cover the whole canvas with paint: feel free to let some of the primer show through.

9. Using a size 4 flat brush, add highlights to the quarry in the bottom left of the painting with a strong mix of cadmium yellow, cadmium red and titanium white. Tighten the ground, reaffirming the relationships between the colours, but making sure the different areas of colour are kept distinct.

Tip

In these final stages, you can simply move and blend the paint already on the canvas rather than adding more.

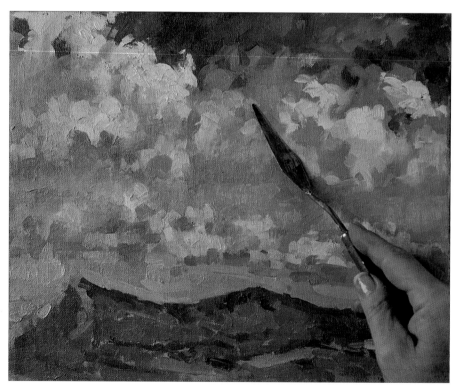

10. Use the painting knife to gently scrape excess paint between areas, helping to blend the paint together. Paint the hedgerows with a size 2 round brush and a dark blue-green mix of French ultramarine, yellow ochre and cadmium yellow. Strengthen the warm fields with a mix of cadmium yellow, cadmium red and yellow ochre.

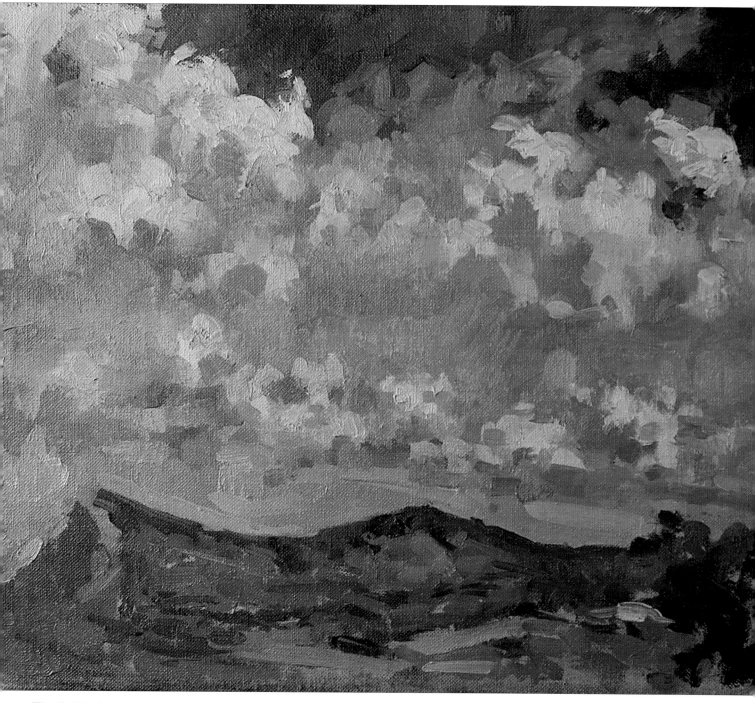

The finished painting

30.5 x 25.5cm (12 x 10in)

This is a study in fleeting cloud structures. Notice how the intensity of the blue in the sky increases the higher it goes.

Camping

45.7 x 38cm (18 x 15in)

The sky in this painting was a real challenge. Initially it seemed to be a sheet of grey but after some time spent simply observing it, I began to notice the slightest nuances in what at first seemed like blanket grey.

Low Cloud on the Mountains, Pollensa

35.5 x 30.5cm (14 x 12in)

Anywhere you find hills, you will also find interesting cloud structures. Here the clouds form layers that recede across the tops of the mountains. It is worth remembering that layers of cloud are in the horizontal plane in reality – i.e. they are parallel to the ground. When we look at a sky, the clouds just appear to go up.

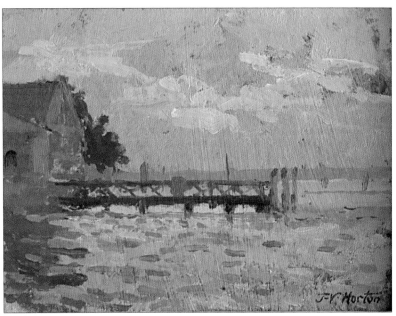

Sunset from Madonna del Orto, Venice

20.2 x 15.2cm (8 x 6in)

This little painting was done swiftly on the spot, paying particular attention to the relationship of the sky to the water. Reflections in water from the sky are always fascinating.

WATER

Water is of perennial interest to painters. Whether sea, river or lake, the challenge of painting water convincingly is one of the most difficult aspects of landscape painting. Perhaps what attracts us to water is the business of reflections. Like moving clouds, rippling reflections need a technique of 'freeze frame' within your mind's eye. This is so often a case of more looking, less painting. The more you understand the structure of the thing you are going to paint the more likely you are to paint it successfully.

Most water is clear – it is what is around it that affects its apparent colour. For example, puddles are conditioned by the pavement, road or soil that they lie on, and a mill pond will appear dark because of the muddy bank. Light from above also affects the appearance and colour of water. The examples on these pages demonstrate this well.

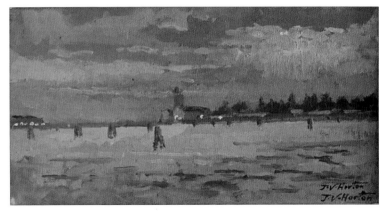

Sunrise over San Michele, Venice
28 x 15.2cm (11 x 6in)

Although sunrise in Venice is somewhat of a cliché, the huge expanse of sky and water creates the most wonderful layering of colour. Notice how at the horizon the sky is darker than the sea; very unusual, and also attractive.

Bridge and Beach Huts – Walberswick
61 x 45.7cm (24 x 18in)

This picture shows a river reflection neither still nor particularly churned up. Although the reflections show the objects reflected very clearly, care has to be taken to keep the structure of ripples within the water.

Cliffs and Sea

This is a painting about reflections in a sea with gently undulating waves. The aim in this project is to understand how reflections work in strong sunlight on a typical blue, Mediterranean coastal bay.

You will need

Canvas board, 40.5 x 30.5cm (16 x 12in)

Medium mix (see page 13)

Brushes: size 2 round, size 2 flat, size 4 flat

Colours: French ultramarine, titanium white, permanent rose, lemon yellow, Venetian red, yellow ochre, ivory black, phthalo blue, cobalt violet, cadmium red, cadmium yellow,

Clean rag

Tip

Reflections in still water are always in a proportion of one to one. However, as ripples occur, the refraction of light causes the reflections to get longer.

Useful mixes on the palette

Earthy green mix

Cliff and beach mix

Sea shading mix

Cliff shading mix

Shadow mix

Sky mix

Wet rock mix

Sea mix

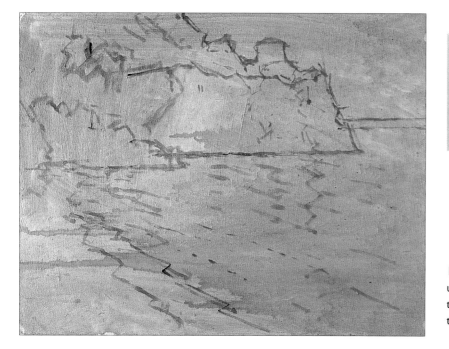

Tip

Reflections in water will always absorb light, especially murky water, so the object reflected will generally be a little darker than its real counterpart.

1. Using a size 2 round brush and French ultramarine, sketch in the main shapes of the cliffs, the beach and the foliage in the top left.

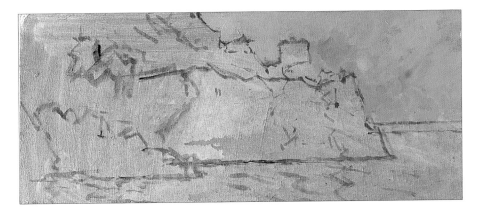

2. Change to a size 4 flat brush, and mix titanium white with French ultramarine. Use this to paint in the sky at the top right. Add a spot of permanent rose to the mix to vary the colour and add interest.

3. Add phthalo blue to the sky mix and begin blocking in the sea, starting from the horizon. As well as varying the tones on the sea by adding touches of lemon yellow and permanent rose, vary the length and speed of your brushstrokes. Both of these techniques will help to avoid a flat finish to the sea.

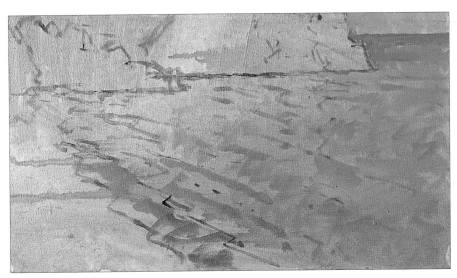

Tip
Scumbling is the use of paint thinned only slightly, and then dragged across a surface such as canvas to give a broken texture.

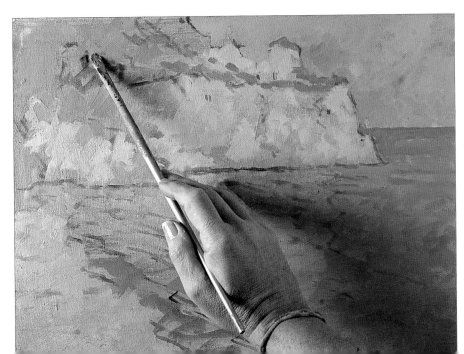

4. Block in the cliffs with a size 4 flat brush, using an earth tone mix of titanium white, Venetian red and yellow ochre. Add touches of lemon yellow and cadmium red for variety, and add more Venetian red and yellow ochre for shading. Use these same colours to block in the beach and for the reflections beneath the cliff. Add more yellow ochre and lemon yellow to the mix to provide a base for the foliage.

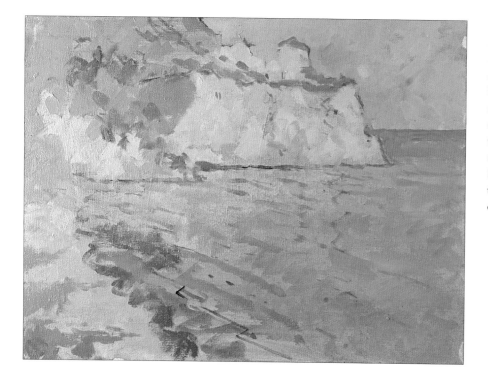

5. Build up the foliage by mixing the sky mix (titanium white and French ultramarine) with the foliage mix for earthy greens, then add a touch of ivory black to darken the colour for the wet sand of the beach. The purpose of these early stages is to approximate the colours that will then be tightened and further refined as the painting progresses. Add French ultramarine and permanent rose to the sky mix for the major areas of shadow on the left of the painting.

6. Mix lemon yellow and French ultramarine with titanium white, phthalo blue and cobalt violet to get a grey-purple colour to define the wet and exposed rock at the base of the cliffs. Switch to a size 2 round brush and use a very light tint of this grey mix to suggest the breakers and crests of the waves. Cobalt violet added sparingly reduces the otherwise stark quality of the titanium white.

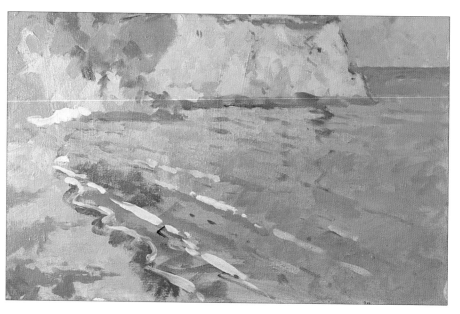

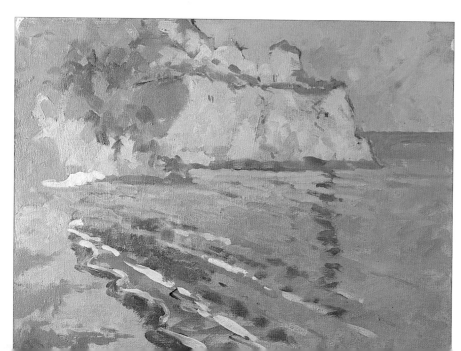

7. Add lemon yellow and titanium white to the earthy green mix used to paint the cliffs. This produces a lighter tint to highlight and refine the cliff shapes. Paint the reflections in the sea using this, adding cadmium red for a rosier hue on the reflections in the foreground. Use the wet sand mix from step 5 for darker reflections to strengthen the impact of the sea.

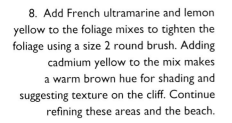

8. Add French ultramarine and lemon yellow to the foliage mixes to tighten the foliage using a size 2 round brush. Adding cadmium yellow to the mix makes a warm brown hue for shading and suggesting texture on the cliff. Continue refining these areas and the beach.

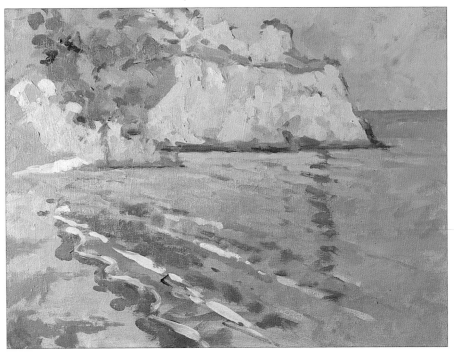

9. Continue blending and teasing the colours of the beach into each other to soften the sharp transitions between areas of paint. Use a size 2 flat brush in the foliage to introduce smaller, sharper transitions and suggest the density of the vegetation. Texture the cliffs in the background with the titanium white, Venetian red and yellow ochre mix. Make a grey-green mix by adding French ultramarine and lemon yellow to the sky mix, and use long brushstrokes with a size 2 round brush to paint in the shadows of the waves on the water.

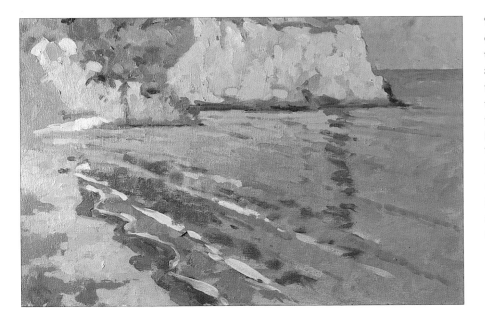

10. Continue detailing the foliage, cliffs and ground with mid-tones of all of the mixes on your palette, varying both the brushes you use and your brushstrokes. Ensure you are happy with the cliffs before you start detailing the sea, as everything that you change later will have to be duplicated in the reflection.

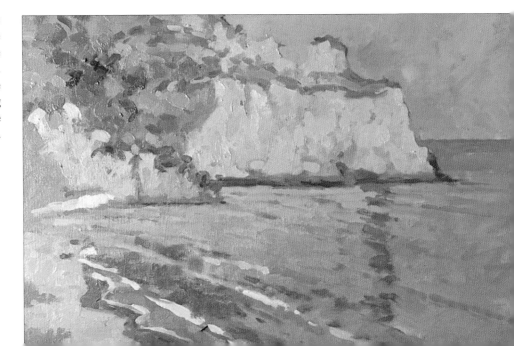

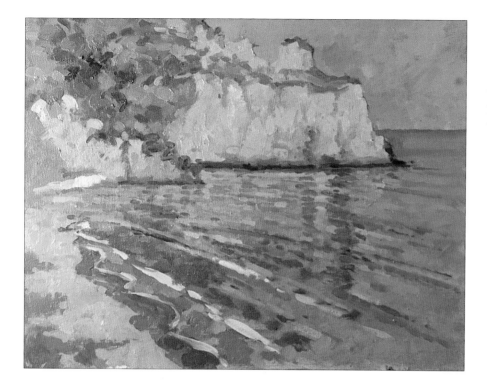

11. Switch between size 2 round and size 2 flat brushes while tightening the overall picture. Use the original mixes for the sky, sea and beach, varying each mix with touches of French ultramarine, cadmium yellow, yellow ochre and permanent rose to vary them and add interest.

12. Make lighter tints of the new mixes on your palette by adding titanium white, and use them to add smaller details on the sea with the corner of a size 2 flat brush. Short, tight brushstrokes suggest the movement in the sea swell.

13. Use a size 2 round brush to add light tints to the sky to suggest faint cloud cover and break up the flat expanse. Small crests on the waves made with French ultramarine, phthalo blue and titanium white enliven the foreground. Finally, take the flatness out of the shadows on the beach with a lighter tint of French ultramarine, Venetian red and titanium white.

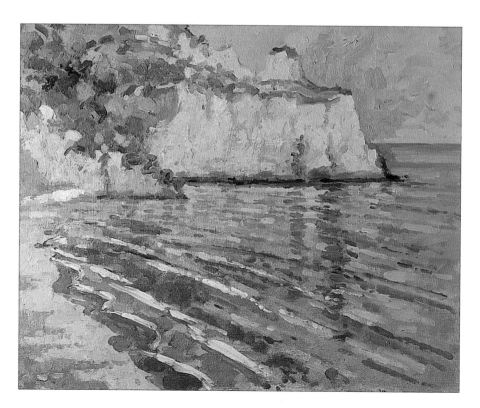

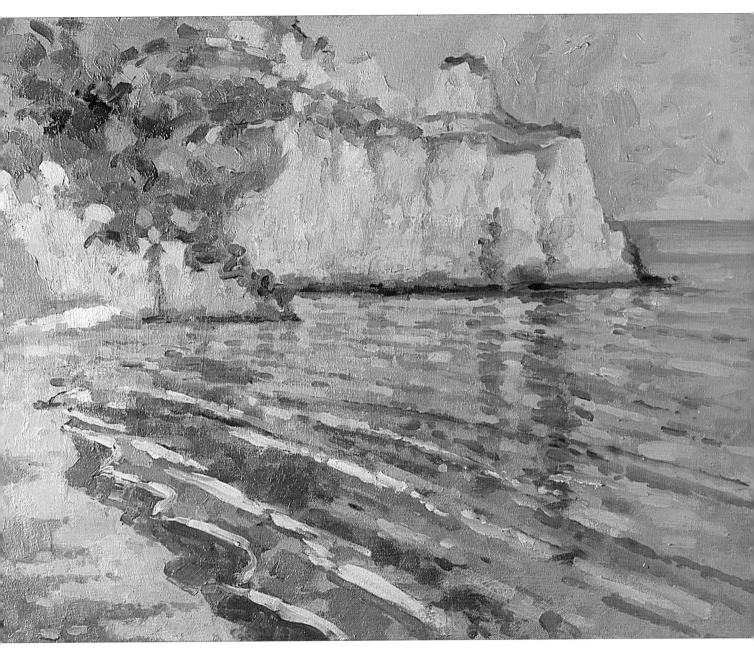

The finished painting

40.5 x 30.5cm (16 x 12in)

The finished painting shows how the reflections in the sea must relate to the object they are reflecting across a broken water surface. Because the water has ripples and waves, the reflection is broken and hence becomes longer than the actual height of the cliff.

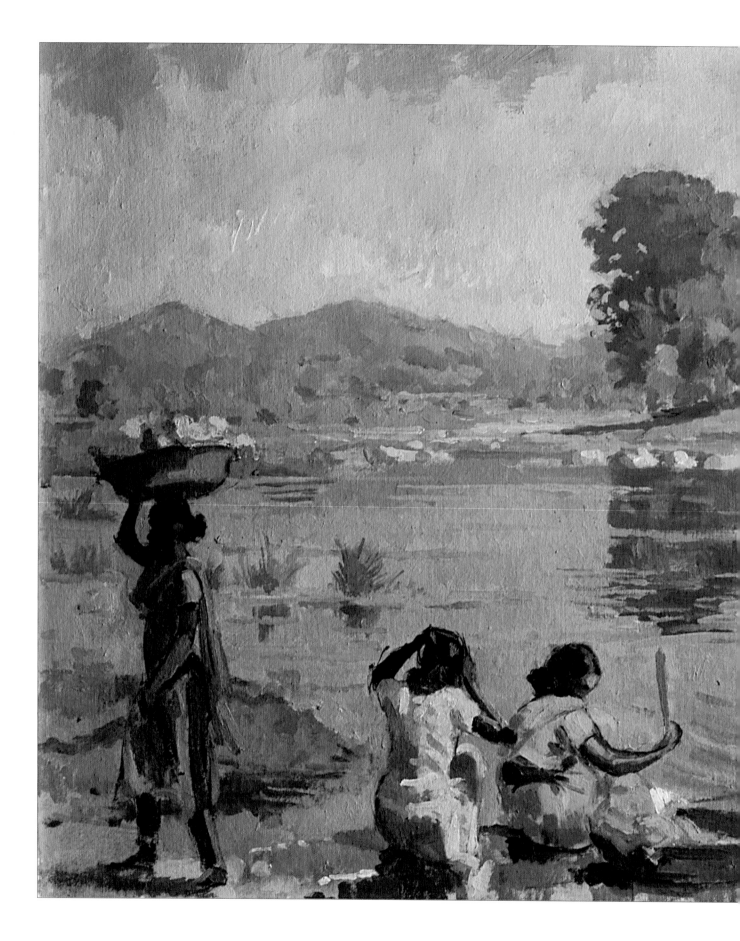

San Vincente, Majorca

40.5 x 30.5cm (16 x 12in)

The colour of the sea is largely dependent on the sky. Here is a typical Mediterranean beach with that ever-present turquoise look. However, because the water is clear, light penetrates further and picks up colour from the shallows.

Poshina Girls Washing by River

45.7 x 38cm (18 x 15in)

This painting was done entirely on the spot. As figures were introduced, I wanted to arrange them so that they did not blot out too much of the water that I liked so much. When putting figures in a landscape, careful attention must be paid to the eye level to ensure that they do not dominate the composition and detract from the landscape itself.

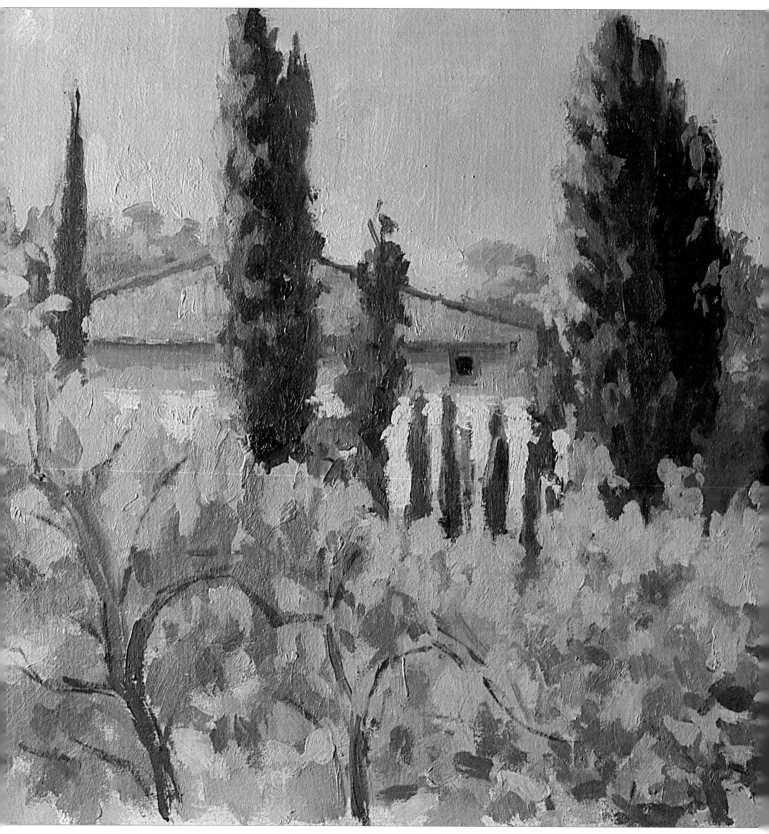

The Villa del Monte, Rufina, Tuscany

40.5 x 30.5cm (16 x 12in)

In this typical Tuscan scene the warm greens of the pencil-like Cypress trees contrast well with the cool blue-grey greens of the olive grove in the foreground. To show the difference in these colours it is essential to identify the individual trees correctly and to create artistic diversity.

In classical landscape painting, trees were portrayed as fluffy-edged and nondescript until John Constable showed the difference in species. He also showed how foliage comprised many different types of green and not just a uniform brown as was previously the case.

The subsequent rise in the status of landscape painting has made painters much more aware of these aspects of trees and foliage today. Just as the specific shape of a tree is important, so is its colour. Foliage also comes in all shades of green and the nuances need to be carefully observed if a convincing result is to be achieved.

Spring from Can-Xenet, Majorca

68.5 x 56cm (27 x 22in)

Despite the autumnal colouring in the tree it is in fact spring growth. This is a good example of how one should never take anything for granted and observe freshly and honestly each time.

Trees on the Fen

The predominant feature here is the difference between the various types of tree. Being able to portray the shape and colour of the individual tree types is essential to give this very English scene its character. In particular, the rendering of greens, both in the foliage and grass, is a great exercise in colour mixing.

You will need

Canvas 45.7 x 35.5cm (18 x 14in)

Medium mix (see page 13)

Brushes: size 2 round, size 4 flat, size 4 filbert

Colours: French ultramarine, ivory black, phthalo blue, cobalt violet, permanent rose, cadmium red, yellow ochre, Venetian red, cadmium yellow, lemon yellow, titanium white

Medium painting knife

Clean rag

Useful mixes on the palette

Basic sky mix
Cloud mix
Tree trunk mix
Warm conifer mix
Cool conifer mix
Foliage mix
Sky mix
Grass mix
Willow mix

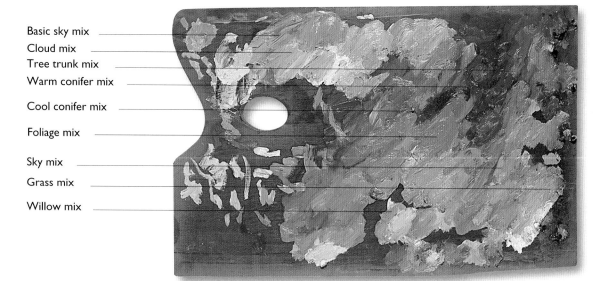

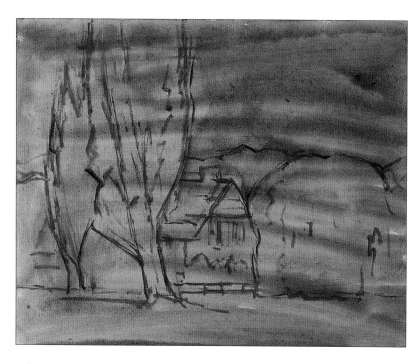

1. Sketch out the initial outline using French ultramarine and a size 2 round brush.

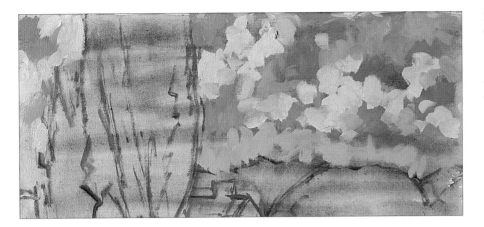

2. Use a size 4 flat brush to paint the sky with a mix of permanent rose, French ultramarine and titanium white. The lightest tints should be at the bottom of the sky, while a darker shade with less titanium white should be at the top. Paint in the clouds with a mix of titanium white and lemon yellow. Vary the colour by combining it with the sky mix. Try to build the relationship between the dark and light blues of the sky and the more yellow colour of the clouds.

3. Make a mix of lemon yellow and French ultramarine, then knock it back with yellow ochre to create the basis for the weeping willow on the right. Add more yellow ochre to break up the shape, then add French ultramarine and a touch of ivory black to create a basis for the distant conifers. Warm this conifer mix with yellow ochre and paint the conifer in the foreground. Paint the trunk in with a mix of ivory black, cadmium red and titanium white.

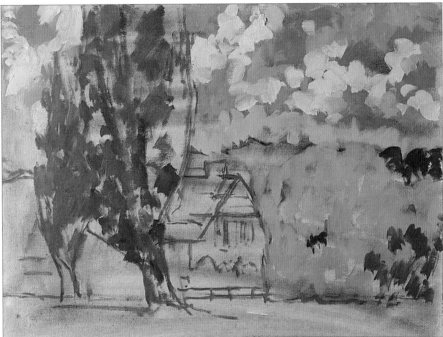

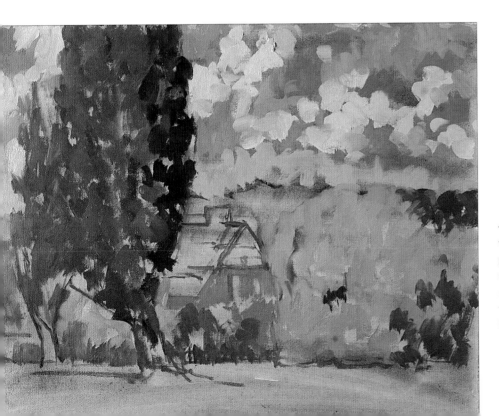

4. Still using a size 4 flat brush, combine the trunk mix with the sky mix and paint the front of the house. Add French ultramarine with the mixes you have made for the foliage to get muted greens that are perfect for shading the trees and bringing the brighter shades forward.

5. Paint in the foreground grasses, using earthy tones made from combinations of the foliage mixes used in steps 3 and 4, varied with the addition of lemon yellow, yellow ochre and French ultramarine. Paint in the roof of the building using a mix of cadmium red, yellow ochre and titanium white.

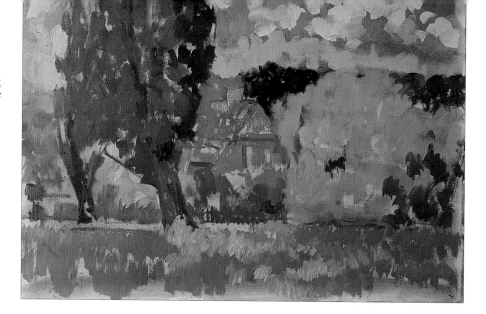

6. Begin tightening the greens and browns in the foliage and foreground with a size 4 filbert brush. Fill in the spaces in the sky where the primed canvas shows through using the cloud and sky mixes, varying and blending the colours.

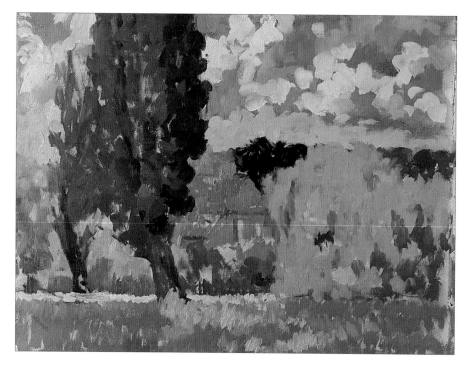

7. Using a size 2 round brush, add browns into the foreground and foliage by combining the sky mix and the foliage mixes on your palette with Venetian red for a rich dark brown; perfect for shading the tree trunks.

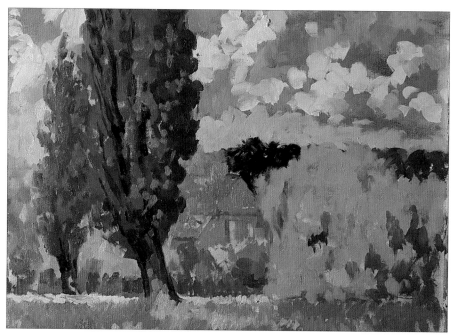

8. Touch in the details on the front of the building with a very light tint of the sky mix. This will ensure that the building does not fade completely into the background, but has a more important role in the final composition.

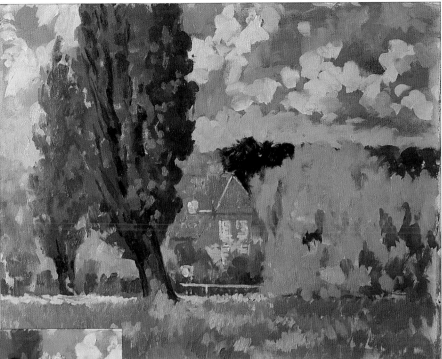

9. Use the cloud mix and a size 2 round brush to paint flecks of sky showing through the central conifer. Use the sky mix to vary the effect.

10. Paint the central poplar's shadow with a dark shade of your foliage colours. Begin tightening up each of the major sections by blending and working the paints on the canvas. Make sure you keep each section distinct from the others: blend only within each separate part, not between them.

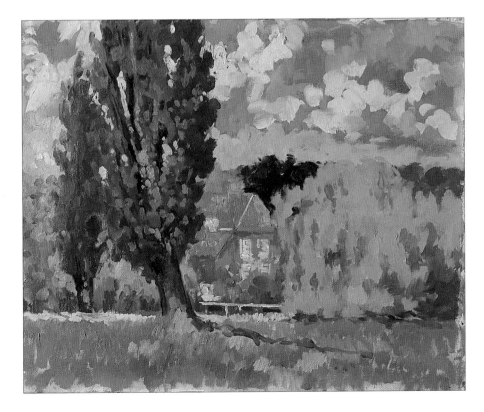

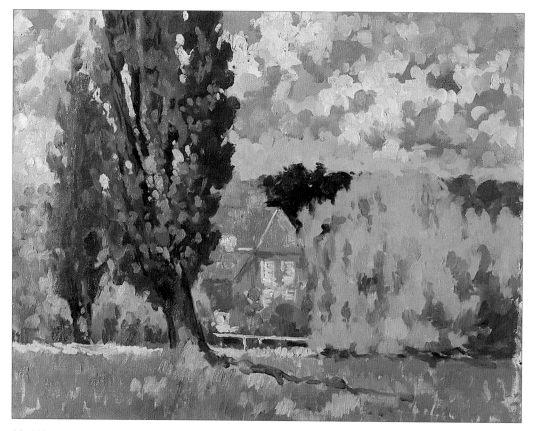

11. Work on the cloud and sky sections using a size 4 filbert brush, paying particular attention to the mid-tones. Switch to a size 2 round brush and tighten the sky areas still further. Go back and tighten up the tree on the left-hand side of the painting.

12. Use the painting knife to smooth the sky, then vary the tones on the painting with a size 2 round brush and very small, tight brushstrokes. Use short, vertical strokes to paint longer grasses in the meadow.

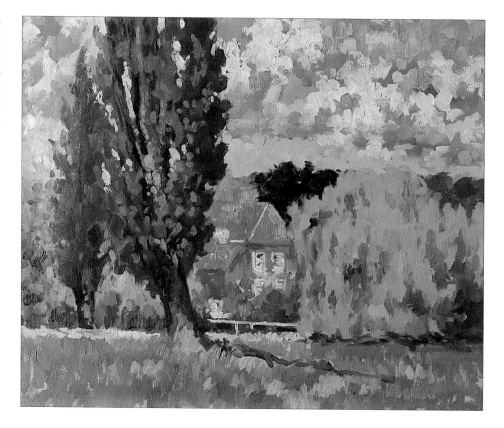

The finished painting

45.7 x 35.5cm (18 x 14in)

This is a typical East Anglian location with a variety of trees. Note how important it is to show the difference in colour between each type of tree.

The Old Cemetery, Roquebrun, France

20.2 x 25.5cm (8 x 10in)

The warm olive-green colours of the tree contrast nicely with the bluish hills and grey variables of the stone. This is a fairly simple idea using the shape and colour of the tree to punctuate the other colours. It is worth noting that this painting is reproduced at almost actual size; which shows the texture of the paint very clearly.

View from the Villa del Monte, Rufina, Tuscany

28 x 35.5cm (11 x 14in)

This painting was a huge challenge in trying to separate out the enormous variety of greens in the landscape and foliage. Notice how aerial perspective is used and is most effective.

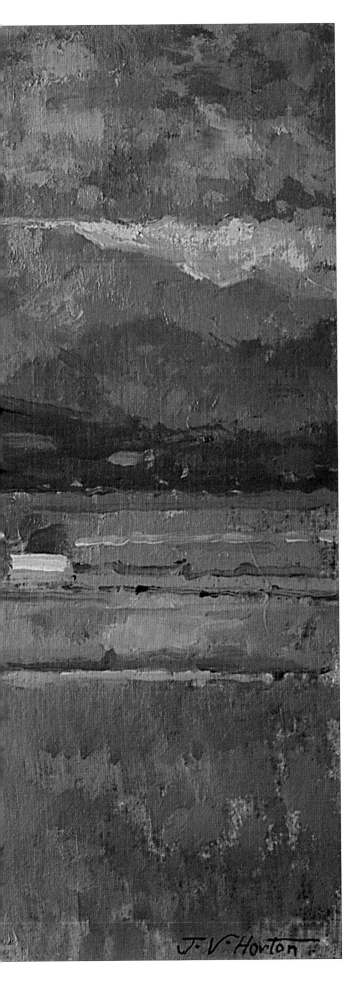

Anywhere there are hills and mountains you can be sure of a great variation in light and atmosphere. Cloudy skies are often found around hills and create interesting scenes. As with any other aspect of objective painting there is no real formula for painting hills and mountains, but one thing to watch out for is how mountains can change their apparent position in space according to the light. In sharp sunlight they are well-defined, with plenty of colour; but in bad light or evening time they can be blue or grey and difficult to place. This can then result in a wide range of potential colour.

Perhaps no other subject contains such a wide variety of the effects of aerial perspective as mountains. Mountains constantly change their appearance throughout the day, providing a permanent challenge for the painter to register their pitch accurately.

Cloud Over the Mountains from Can-Xenet

35.5 x 30cm (14 x 12in)

Like Cézanne I have enjoyed painting the same range of mountains in all their variations and many of the pictures appear in this book. In this instance the cloud was heavy and sitting along the top of the whole range. This has the effect of lowering the tonality of the whole picture. Notice how light the house and outbuildings are against the dark surroundings.

Mountain Bay

This picture is primarily about the relationship of the sky, mountains and the water in the bay. However, the inclusion of the sunbathers and their brightly coloured swimming costumes is a wonderful chance to create complementaries against the blue of the water.

You will need

Canvas 45.7 x 35.5cm (18 x 14in)
Medium mix (see page 13)
Brushes: size 2 flat, size 4 flat,
Colours: French ultramarine, ivory black, titanium white, phthalo blue, Indian red, cadmium yellow, cadmium red, raw sienna, cobalt violet, lemon yellow and permanent rose
Clean rag

Useful mixes on the palette

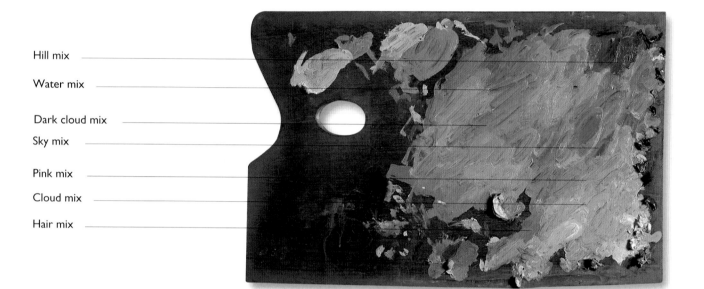

Hill mix

Water mix

Dark cloud mix

Sky mix

Pink mix

Cloud mix

Hair mix

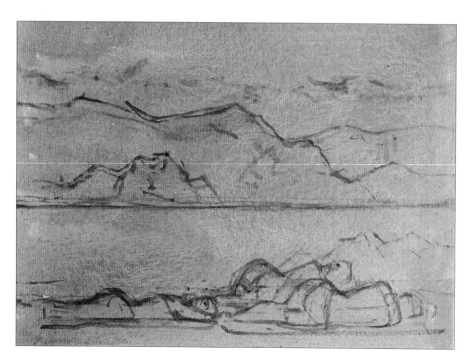

1. Use thinned French ultramarine and a size 2 flat brush to sketch in the main areas of the picture.

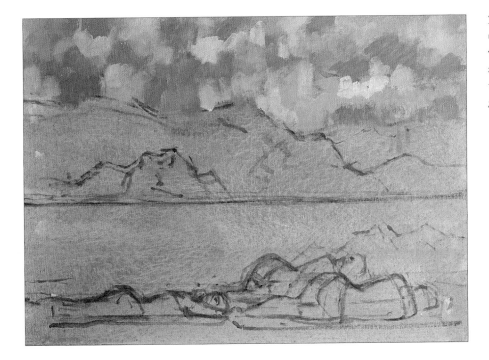

2. With a size 4 flat brush, mix French ultramarine, ivory black and titanium white with a touch of phthalo blue for a sky mix, and apply to the top of the painting. Vary the tones by adding Indian red and palette grey (see page 23) to the basic mix.

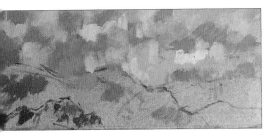

3. Add spots of this mix to the hills. Vary this with touches of French ultramarine, phthalo blue and cadmium yellow.

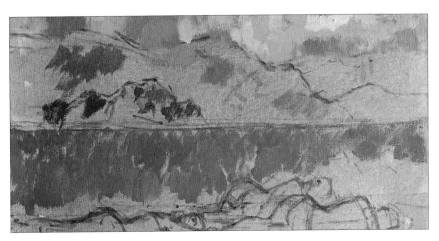

4. Darken the sky mix with French ultramarine, phthalo blue and cadmium yellow, and use this mix to block in the water in the bay. Add cadmium red as the water nears the hills.

5. Begin to add to the hills with variations and combinations of the sea and sky mixes. Create a pink from titanium white with cadmium red and cadmium yellow and add this to the hills. Add progressively more pink to the hills as they advance, saving the thickest mix for the closest hill.

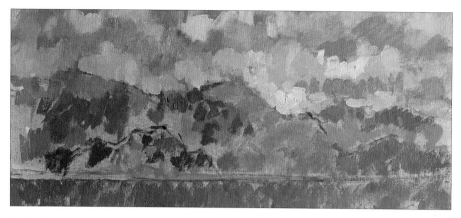

6. Add palette grey to the pink mix and begin to tint the hills with lighter combinations of the mixes. Add titanium white to the mix and begin to paint some loose clouds. Highlight these with the sky mix with added titanium white and cadmium yellow.

7. Use the pink mix with a size 2 flat brush to paint a neat line of sand across the base of the hills to help differentiate the hills from the water.

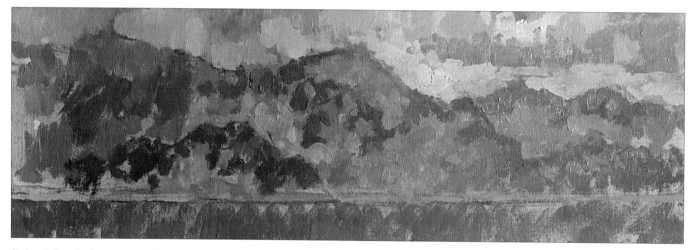

8. Look for the interesting colour combinations in the hills and arrange the mixes on the palette to complement each other, following the cues from your source material.

9. Begin tightening and refining the sky and hills. Use a size 2 flat brush and the pink mix (titanium white, cadmium red and cadmium yellow) with palette grey and titanium white to begin the rocks in the foreground.

10. Adjust and tighten the water, covering any areas of bare canvas with the water mix (French ultramarine, phthalo blue and cadmium yellow) varied with the addition of more French ultramarine and phthalo blue.

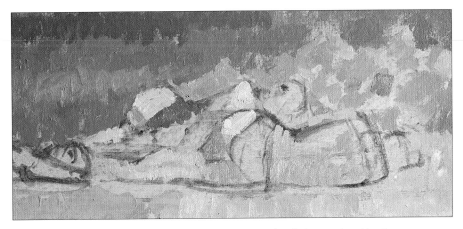

11. Use palette grey to vary the grey sky, and introduce cadmium yellow to the cloud mix to vary the tones. Add this colour to the water mix and touch in areas of the hills on the left.

12. Make a skin mix of titanium white, raw sienna and cadmium red and begin to paint the sunbathers at the bottom right. Add touches of cobalt violet, palette grey and French ultramarine for shading. Begin to paint the red swimming costume with a mix of cadmium red, titanium white and palette grey.

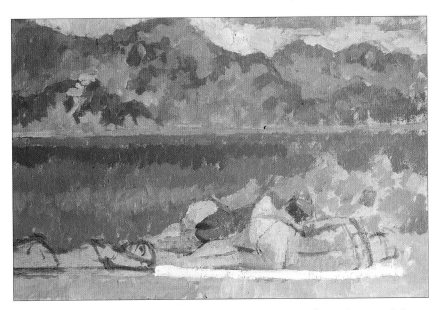

13. Continue painting the red swimming costume, and refining the skin areas. Use an ivory black, lemon yellow and cadmium red mix for hair.

14. Use a combination of the water and pink mixes to cut in the rocks around the sunbathers. Shade the red swimming costume with the addition of Indian red and permanent rose. Block in the yellow bikini with cadmium yellow, and add raw sienna and cadmium red to shade. Block in the beach towel with titanium white.

71

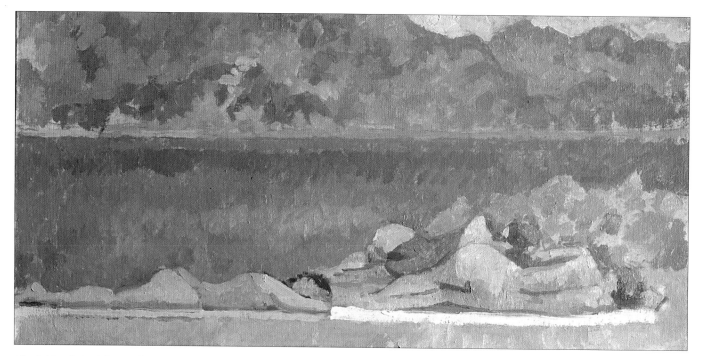

15. Add cobalt violet to the water mix and paint in the cast shadows beneath the figures. Add highlights to the closest sunbather with the skin mixes from steps 12–14. Paint the final sunbather using the same techniques as the other two. Add phthalo blue to the water mixes for her swimming costume.

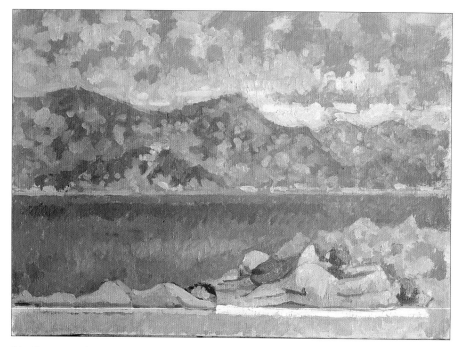

16. Cover any bare canvas with a combination of the hill mix and the pink mix, and tighten the picture now all the tonal values are roughed in.

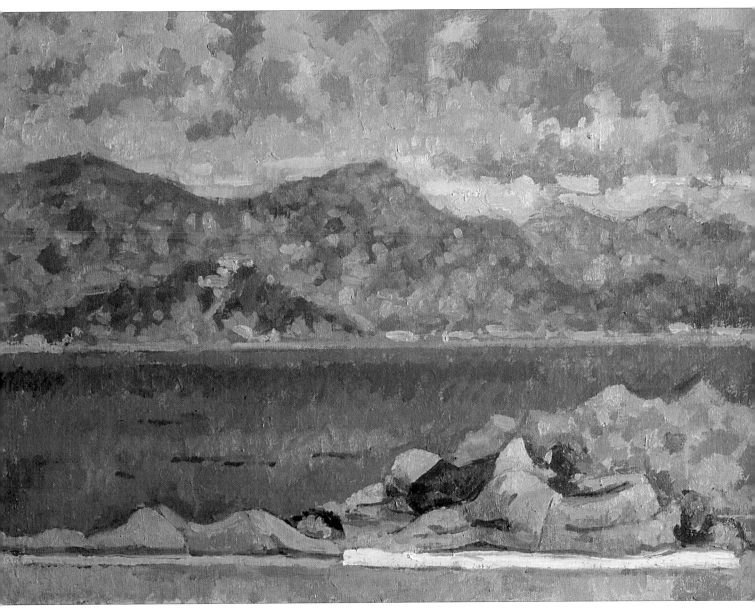

The finished painting
45.7 x 35.5cm (18 x 14in)

Although this painting is primarily about the mountains and the water, the arrival of the sunbathers while I was painting the scene was a great stroke of luck. The red, yellow and blue of their swimming costumes gives an instant complementary colour effect.

Spring Day Near Pollensa, Majorca

63.5 x 53.2cm (25 x 21in)

This was painted on a sharp spring day in Majorca. The range of mountains was clearly lit and showed all the nuances of pinks and purples. However, as so often happens, the clouds clung to the top obscuring the peaks and making the division between cloud and mountain almost impossible to discern. This type of scene needs to be painted as it is seen and not 'tidied up'.

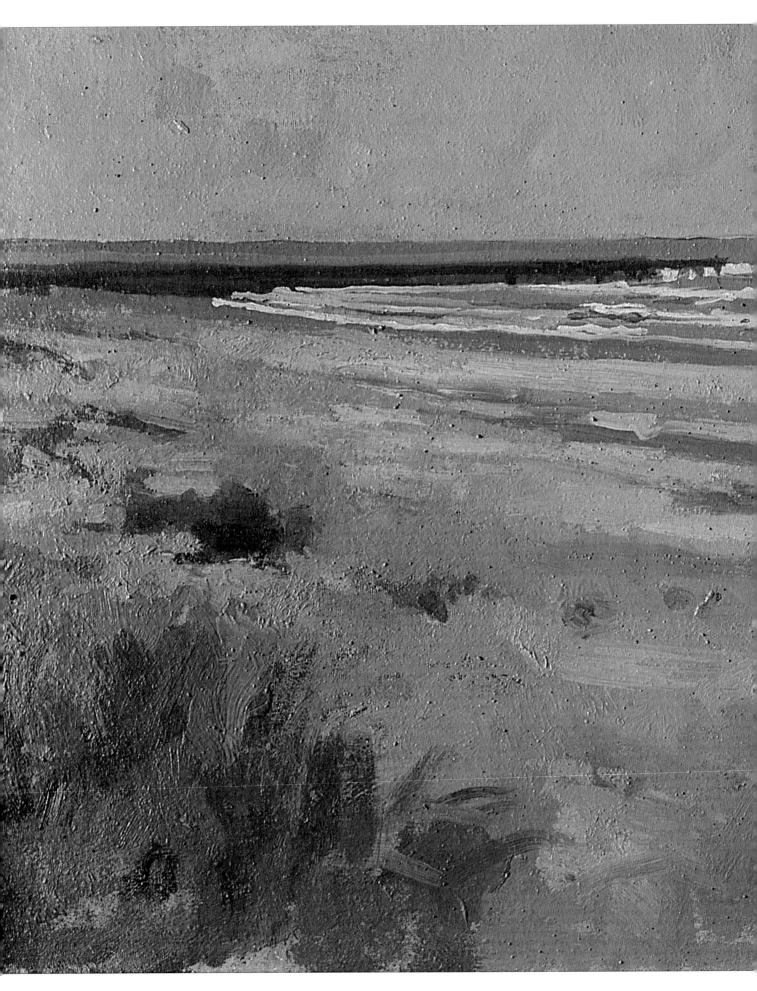

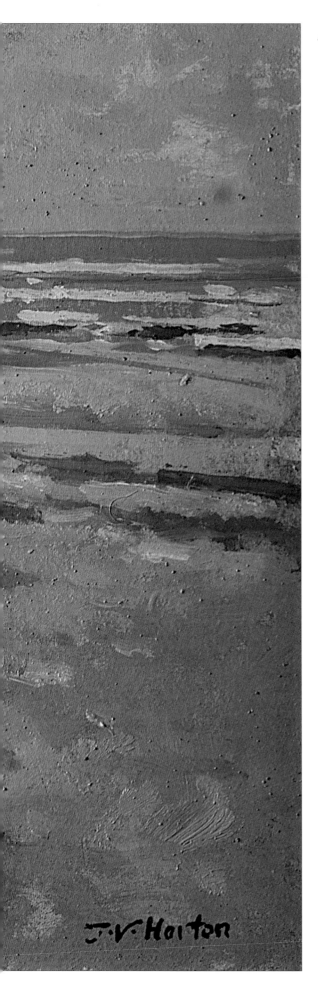

The beach is one of my favourite subjects, and has been one of the most popular among artists for many years. It is almost as though it is a stage with shifting scenery and actors coming and going eternally.

In practical terms the thing to look out for is eye level. Beaches are seldom dead flat and usually rise to some extent giving interesting eye levels, especially if you are observing from a sitting position. Compare the eye levels of the picture on this page with *Late Afternoon at Walberswick Beach* (page 85) for an example of the effect that different eye levels can give to a painting.

Always observe the sea and sky together. Fleeting light can change how they appear very quickly, and it is easy to paint two relatively unrelated parts without noticing. As always, try not to invent: look carefully at the colours that are in front of you and their relationship to each other.

Walberswick Beach

30.5 x 20.2cm (12 x 8in)

This was painted while standing, hence there is more beach, and less foreground foliage than its companion piece on page 85. The tide was receding and exposing areas of wet sand, which temporarily became quite dark. Note the high placing of the horizon to gain more space on the beach. This painting is reproduced at actual size, which enables you to see the texture of the paint and the brushwork in detail.

On the Beach

The beach is often a place where many bright colours can be seen. These will punctuate the more muted colours of the landscape and it is often the case that one can deliberately use complementary colours to enhance the colour harmonies.

 When sketching out your composition, bear in mind that drawing is not just about accurate lines; rather it is about areas of colour abutting one another. The umbrella in this composition is an excellent example of this.

You will need

Canvas board 40.5 x 30.5cm (16 x 12in)
Medium mix (see page 13)
Brushes: size 2 round, size 4 round, size 4 flat
Colours: French ultramarine, ivory black, titanium white, phthalo blue, Indian red, cadmium yellow, cadmium red, raw sienna, cobalt violet, lemon yellow and permanent rose
Medium painting knife
Clean rag

Useful mixes on the palette

Figure mix

Shadow mix

Sea mix

Beach mix

Fence mix

Foliage mix

Basic sky mix

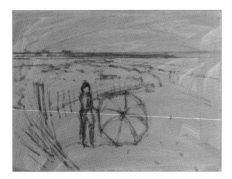

1. Use French ultramarine and a size 2 round brush to sketch out the composition, cutting the sea in on the top right and the fence running in an 'S' shape to the bottom left.

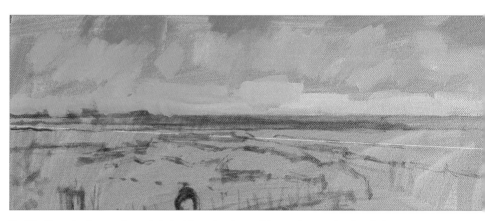

2. Mix French ultramarine, phthalo blue, titanium white and a touch of cadmium yellow for a sky mix. Put the colours down loosely in the sky with a size 4 round brush, adding more cadmium yellow at the mid-levels, and a touch of Indian red for the sky just above the horizon.

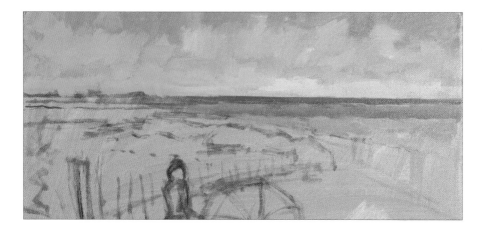

3. Still using the size 4 round brush, add more phthalo blue and French ultramarine to the sky mixes and paint in the sea.

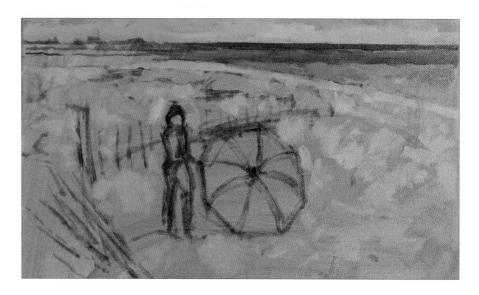

4. Make a beach mix from titanium white, raw sienna and Indian red, and place this mix on the beach. Vary the tones on the beach by adding touches of cadmium yellow, cadmium red and raw sienna to avoid a flat colour.

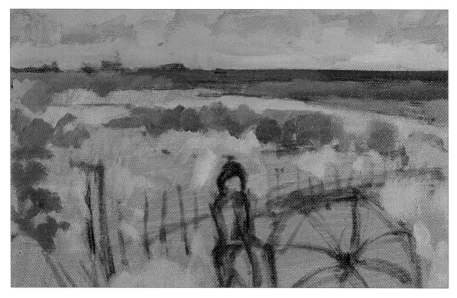

5. Combine the sky mix with the beach mix and add French ultramarine and raw sienna to produce a dull green foliage mix. Use this to begin painting in the scrub on the distant dunes, varying the tone by using greater amounts of cadmium yellow, raw sienna and the beach mix. You can also add Indian red for the brown areas of dead or dry foliage.

6. Use a size 4 round brush to add titanium white and ivory black to the darkest part of the sea mix, and use this dark grey to add the uprights of the fence.

7. Add a little of this fence mix to the sea mix and use this grey-green to touch in texture to the foliage on the left with a size 2 round brush.

8. Continue covering the canvas with the various mixes, and begin to paint the figure. Use a mix of ivory black and Indian red for the hair, then add raw sienna, French ultramarine and permanent rose for the areas of the figure that are in the shade.

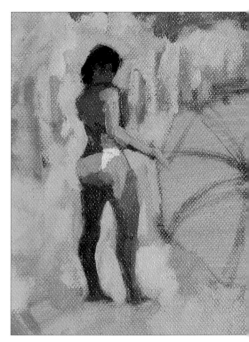

9. Mix titanium white, raw sienna and touches of cadmium red and cadmium yellow for the skin highlighted by direct sunshine. Close up the background around the figure with the beach and fence mixes. Add titanium white and permanent rose to the mix for the figure's bikini.

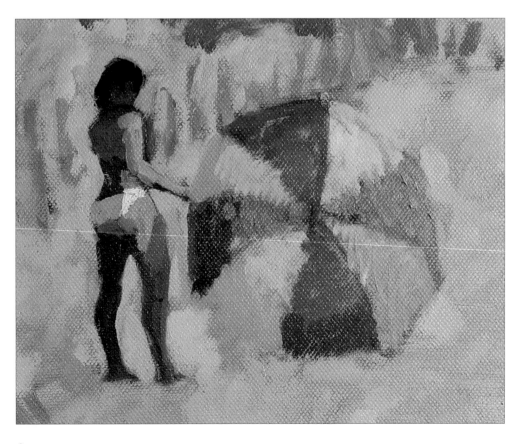

10. Begin to block in the umbrella, using cadmium yellow and raw sienna for the yellow areas. Add cadmium red to this mix for the red areas, French ultramarine for the blue, and a phthalo blue and lemon yellow mix for the green parts. Highlight the umbrella with the addition of titanium white to each of the mixes.

11. With the basic colours laid down, add a touch of ivory black to the fence mix and shade the fence. Use the same colour to lay in the shadow of the umbrella and the figure.

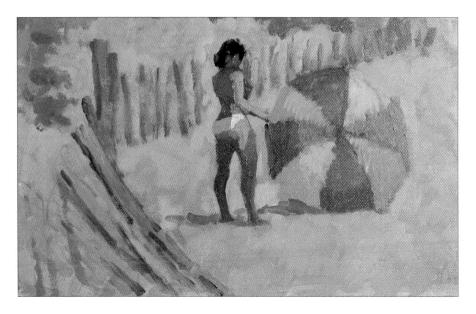

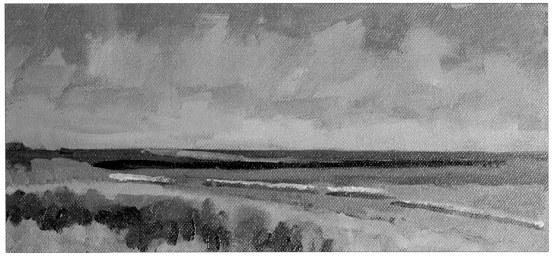

12. Add titanium white and ivory black to the shadow mix, and paint in the pier in the distance, then use the beach mix to paint in the land beyond the pier. Tighten the mid-distance foliage with variations of the foliage mix, adding touches of raw sienna and cadmium yellow to alter the colour. Use this same mix to paint in the wave coming up the beach, and then add a crest with pure titanium white.

13. Paint in the buildings on the horizon. The green building uses the green from the umbrella tinted with white, while the others use muted combinations of the shadow, beach and sky mixes.

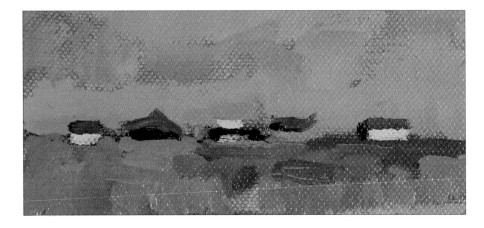

14. Use the sky mix and a size 2 round brush to begin tightening the sky. Alter the tone by adding touches of French ultramarine, titanium white and cadmium yellow in varying quantities. Tint the beach mix with titanium white and a touch of cadmium red and introduce some pink to the clouds.

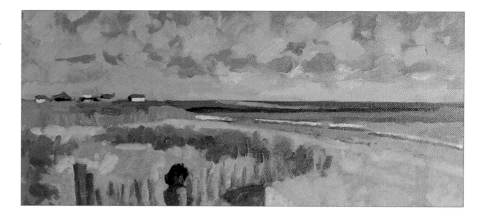

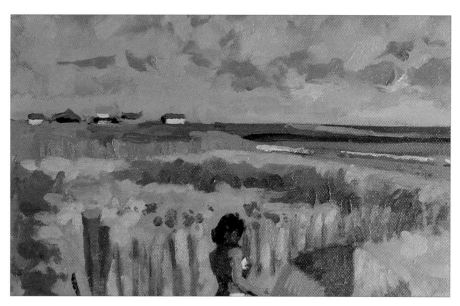

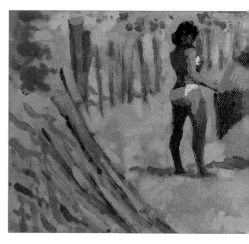

15. Tighten the sandy areas and the scrubby foliage in the middle distance and foreground with combinations of the beach and foliage mixes.

16. Continue working and tightening the fencing and the sand in the bottom left. Deepen the shading on the fence by adding French ultramarine to the fence mix.

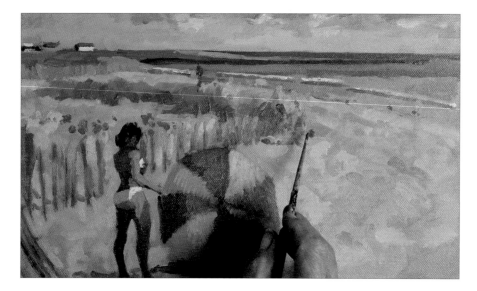

17. Begin painting the figures further up the beach with virtually unthinned paint mixes. Use the colours from the umbrella and the skin tones from the girl in the foreground.

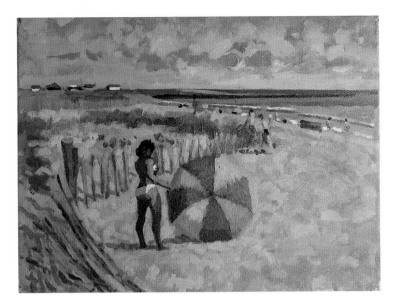

18. Continue using the mixes on the palette to detail the figures on the beach, and then use the painting knife to flatten any hard edges or ridges of paint that have formed.

The finished painting

40.5 x 30.5cm (16 x 12in)

The placing of figures on a beach is always a tricky business. Because the level and height of the beach varies enormously, careful attention must be paid to the relative eye levels of the people of the beach, especially in relation to the observer.

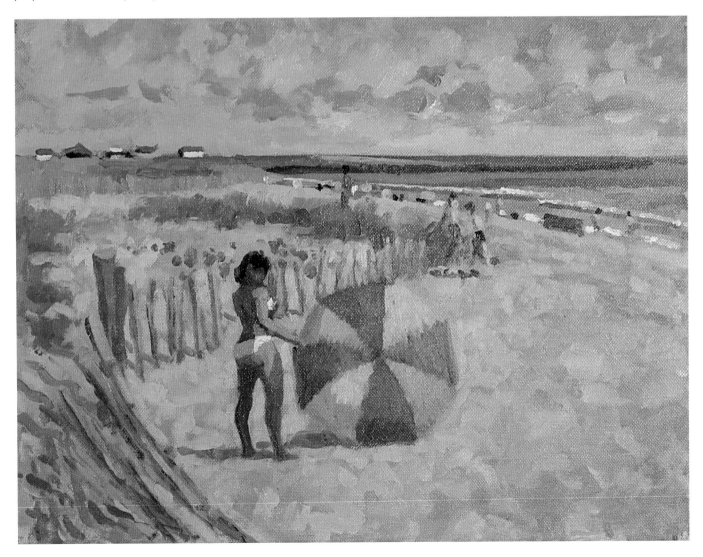

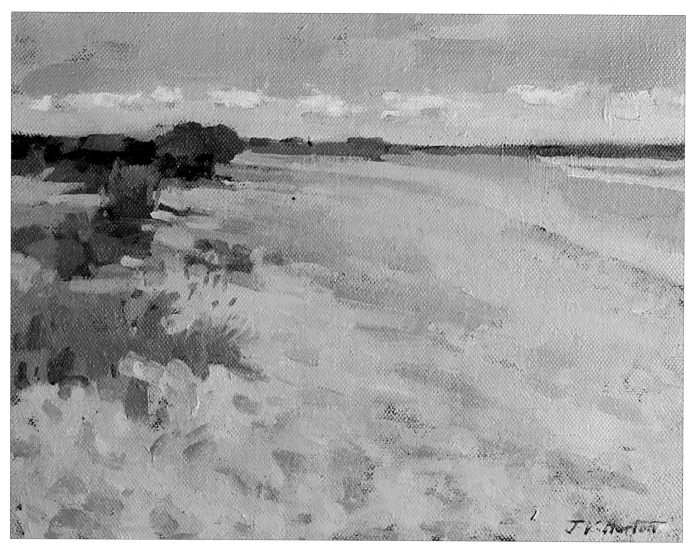

Beach Huts at Walberswick

25.5 x 20.2cm (10 x 8in)

This picture makes use of a high horizon in order to emphasise the colours and shapes of the foreground. Provided the colours are accurate the shapes can be stated quite simply with lively brushstrokes.

<div align="right">

Opposite:

The Dunes, Walberswick

56 x 45.7cm (22 x 18in)

I like the shapes and patterns created by the grasses surrounded by areas of sand. The view of the sea is broken by the grass, which helps to unite the foreground and background. It also emphasises the somewhat low eye level.

</div>

Late Afternoon at Walberswick Beach

25.5 x 20.2cm (10 x 8in)

This is the companion piece to *Walberswick Beach* (page 77) and was painted while seated, which accounts for the relatively small amount of beach and foliage in the foreground. I was particularly interested in abstract shapes that the foliage made in contrast to the straightness of the horizon.

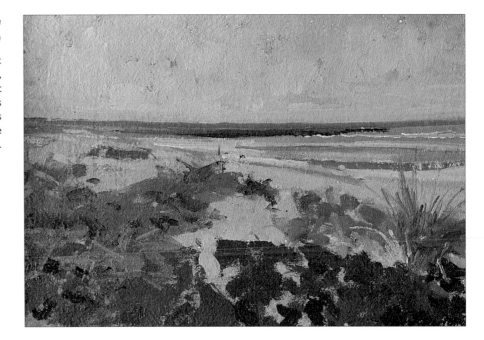

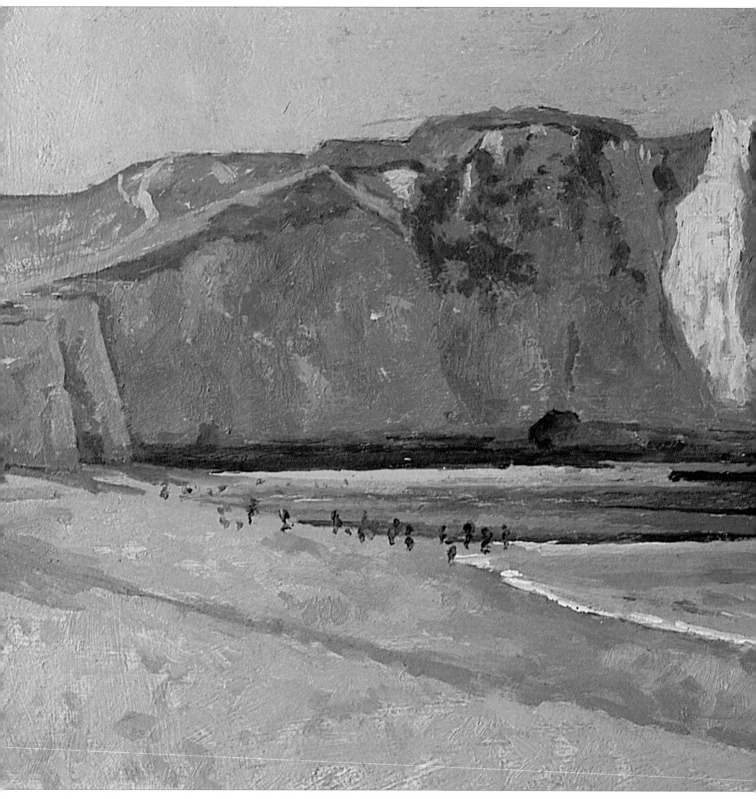

Etretat Beach and Cliffs, France

35.5 x 25.5cm (14 x 10in)

This was painted in high summer on a beautiful clear day. The purplish colour in the shadow on the cliff is a good example of complementary colour when seen against the warm yellow of the sunlit areas of cliff.

The seasons all have their own unmistakeable quality, and if possible I like to work outside – even in winter. Although the working times are restricted because of the cold, it is still enjoyable to work from life because the magic of being on the spot is unbeatable. The thing to remember is to adjust your aims to the environment and practical limitations. Even thirty minutes of direct observation is better than any photograph, especially if you can record the vital elements of a scene.

It is the issue of colour that should always be uppermost in your mind. If necessary, a photograph can help with factual information but wherever possible try to make the colour your own – even if you only have time to make colour swatches for reference.

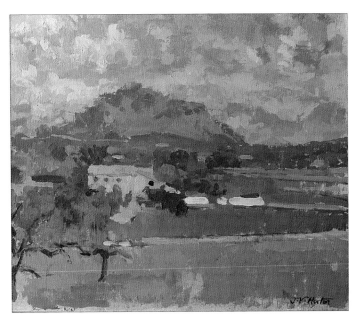

The Old Farmhouse from Can-Xenet, Majorca
30.5 x 25.5cm (12 x 10in)

Although painted in spring, this scene looks more autumnal. However, there is often very heavy rain in Majorca at this time of year and the clouds are wonderful to paint. At any other time of year the two foreground fields would be a parched sandy brown, not green.

Rooftops in the Snow

Painting in the winter is a great challenge, especially in the snow. Normally the amount of reflected light is much less, and the actual 'white' content far greater. This can affect the key or pitch that your painting acquires.

You will need

Canvas board 40.5 x 30.5cm (16 x 12in)

Medium mix (see page 13)

Brushes: size 2 round, size 2 flat, size 6 flat, size 7 filbert

Medium painting knife

Colours: French ultramarine, ivory black, titanium white, phthalo blue, Indian red, cadmium yellow, cadmium red, raw sienna, cobalt violet, lemon yellow and permanent rose

Clean rag

Useful mixes on the palette

Foreground tree mix

Green mix

Upper sky mix

Brickwork mix

Lower sky mix

Snowfall mix

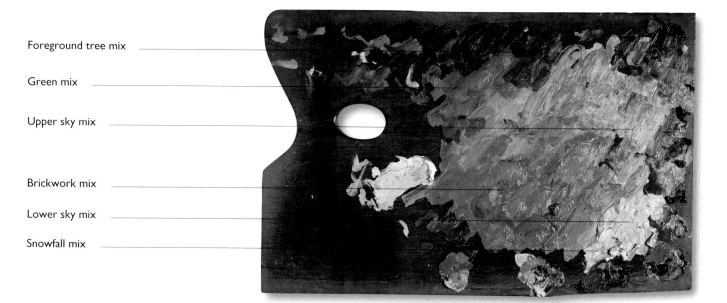

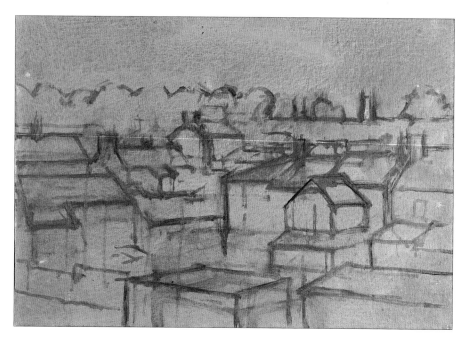

1. Sketch out the composition with a size 2 round brush and thinned French ultramarine. When painting buildings the initial sketch must be correct, with everything set out in the right place, or later stages become very difficult. For this reason, it is worth spending some extra time on this stage before moving on to the next step.

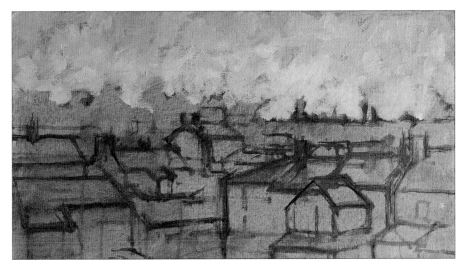

Tip
It is important to keep an eye on the overall composition, as well as the detail you are adding at any one time.

2. Use the size 6 flat brush and titanium white mixed with a little cadmium yellow and a touch of cadmium red to block in the bottom of the sky. Use agitated brushstrokes to spread the paint around. Make a mix of titanium white and French ultramarine for the top of the sky.

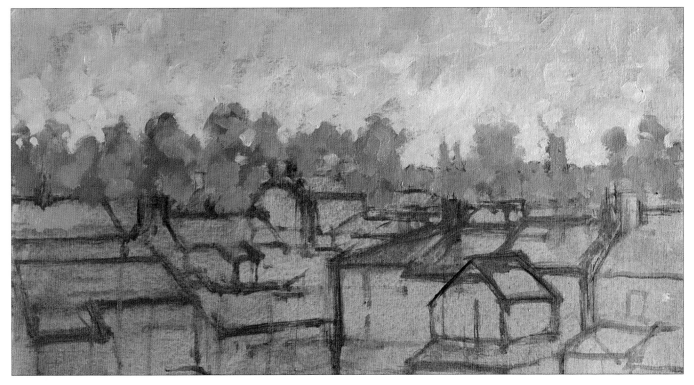

3. Mix small amounts of cadmium red, cadmium yellow, French ultramarine and cobalt violet into your palette grey, and use a size 7 filbert brush to block in the horizon area. Vary this by combining it with the upper sky mix (titanium white and French ultramarine) and a greyed-down version of the lower sky mix.

4. Make a shaded snowfall mix by adding a touch of phthalo blue to French ultramarine and titanium white. Use this to paint the darker roofs on the composition, then use the sky mixes to paint in the other roofs.

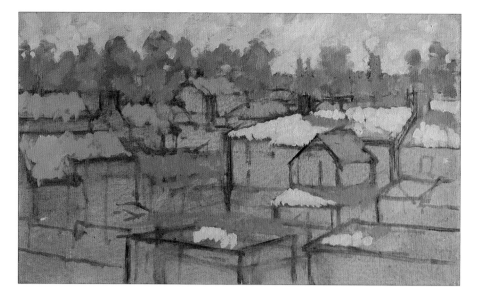

5. Make a brickwork mix from French ultramarine, ivory black and raw sienna. Paint this on to some of the buildings, varying the tones by adding raw sienna. Continue using the sky mixes to cover areas of bare canvas, and mute the stronger tones at the bottom of the painting by adding palette grey to your mixes.

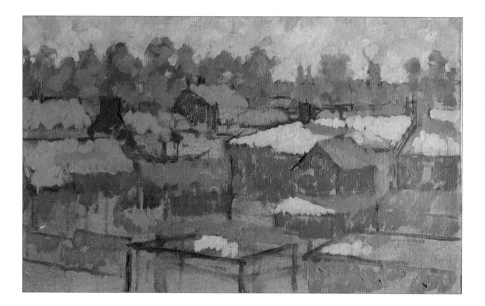

6. Use ivory black, phthalo blue, cadmium yellow and lemon yellow to make a green mix. Use this to paint in the ivy on the walls, varying the mix with raw sienna and differing proportions of the original colours.

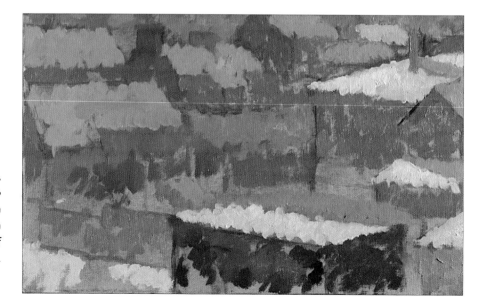

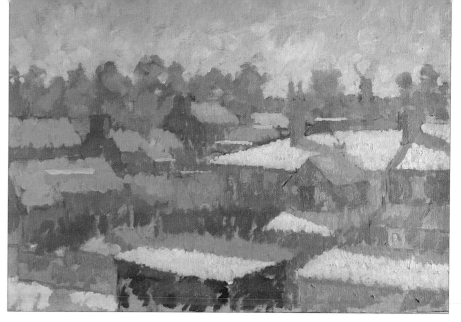

Tip

Note how the use of cadmium red and cadmium yellow in the highlights of the snow warm these areas. These are complementary tones to the cool blues and purples, and their use helps to create a harmonious picture.

7. Use the size 2 round brush with the mixes on your palette to begin tightening the details on the houses, including introducing the suggestion of windows and chimneys.

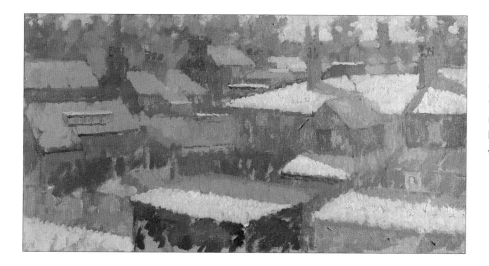

8. Continue tightening the architecture. As with any building work, the shapes must look correct, so refine and tighten the image, use small brushstrokes to ensure neatness. Remember not to mix the areas on the canvas, and instead mix on the palette. Do not blur the boundaries between the buildings. Work within each area of colour in turn.

9. Use a mix of ivory black and Indian red with a size 2 flat brush to paint in the trunks and main branches of the foreground trees. Add these fairly confidently: because you are working over wet paint, reworking will muddy the colours, and you want to minimise this dirtying effect. Vary the tones with more Indian red and cobalt violet.

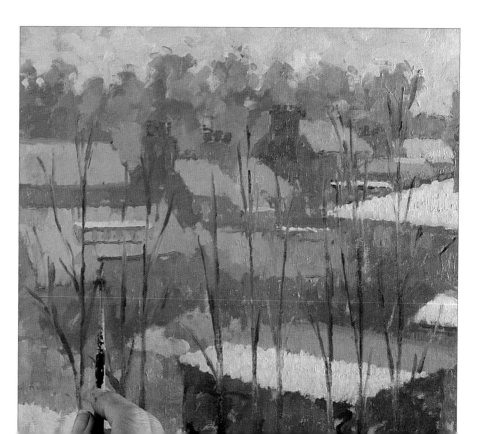

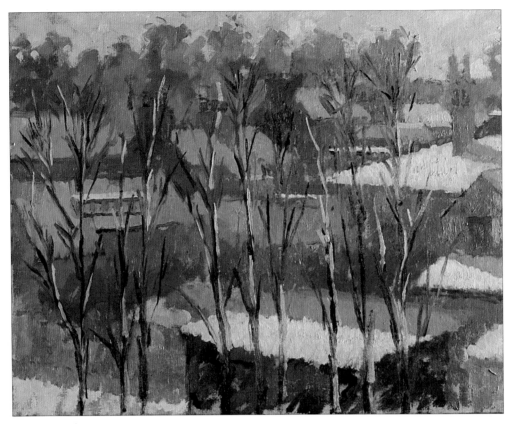

10. Add further smaller branches and begin to detail the trees. Use the sky mixes to suggest highlighting, and snow, on the branches.

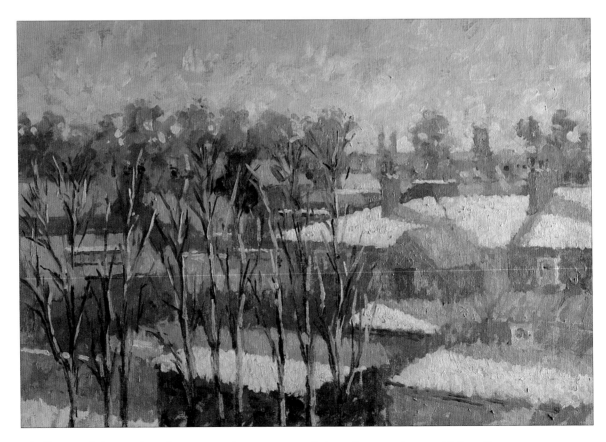

11. Continue balancing the colours across the canvas as a whole until you are happy with how the picture looks, using the mixes on the palette. Vary them with touches of the primary colours.

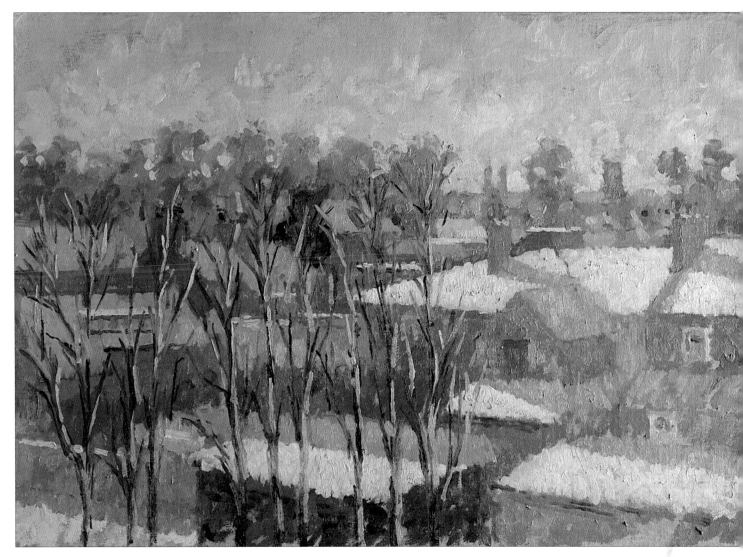

The finished painting

40.5 x 30.5cm (16 x 12in)

Snow is the most wonderful thing to paint because the range of colours is quite different from any other scene. The shadows on the snow are pure blue, and a delicate purple on the distant trees and buildings. Once again, complementary colour plays an important part here with the warm orange of the chimney pots standing out against the surrounding blue.

Darbadgarh Poshina, Gujarat, India

35.5 x 30.5cm (14 x 12in)

In the strong, sharp and intense sunlight of India, the shadows on the building became a strong, bluish purple. In this sort of light, all colours seem to reach their maximum potential. Although this is strictly speaking an architectural subject, I still tried to keep a certain looseness in my handling of the subject.

King's College Chapel, Cambridge

91.5 x 76.2cm (36 x 30in)

It is only possible to paint (or indeed see) this scene in winter when there are no leaves on the trees. The composition uses a strong framework of horizontals and verticals to contain the eye upon the chapel. The winter colours are soft, muted and atmospheric in a way quite different from summer.

INDEX